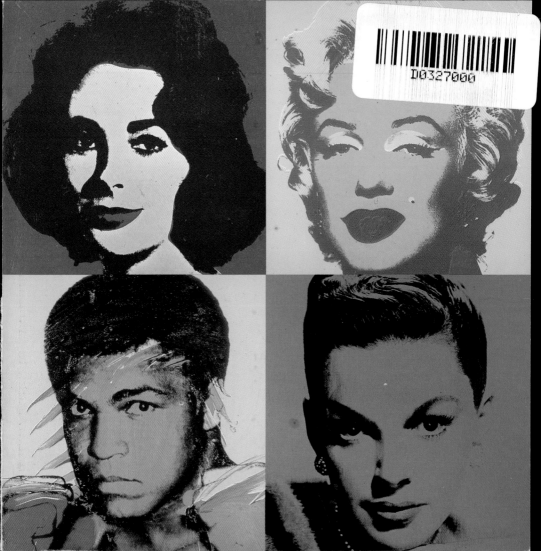
D0327000

Andy Warhol

BY INGRID SCHAFFNER

THE WONDERLAND
PRESS

Harry N. Abrams, Inc., Publishers

THE WONDERLAND PRESS

The Essential™ is a trademark
of The Wonderland Press, New York
The Essential™ series has been created by The Wonderland Press

Library of Congress Catalog Card Number: 99-73516
ISBN 0-8109-5806-6

Copyright © 1999 The Wonderland Press
Except as noted, all works are Copyright © 2000 The Andy Warhol Foundation
for the Visual Arts/Artists Rights Society (ARS), New York

Photo Credits: Except as noted, all photographs are The Andy Warhol Foundation, Inc./Art Resource, NY
Photographs on pages 4, 21, 48, 59 (Gerard Malanga), 67, and 110 are © 2000 by the Estate of
Edward Wallowitch. Photographs on pages 42, 55, 58 (except for Candy Darling, "Baby" Jane Holzer),
59 (except for Gerard Malanga), 60 (except for Ultra Violet), and 72, are © 2000 by Billy Name/Factory Foto.
Photographs of Henry Geldzahler on page 46 © Dennis Hopper. Photograph of Ultra Violet on page 60;
UPI/Corbis-Bettmann. Photograph of "Baby" Jane Holzer on page 58 Santi Visalli Inc./Archive Photos.
Photograph of Nico on page 76: Tim Boxer/Archive Photos

On the end pages (clockwise, from top left): Clint Eastwood, Prince, Elizabeth Taylor,
Marilyn Monroe, Judy Garland, Muhammad Ali, Grace Jones, Howdy Doody

Published in 1999 by Harry N. Abrams, Incorporated, New York
All rights reserved. No part of the contents of this book may
be reproduced without the written permission of the publisher

Unless caption notes otherwise, works are synthetic polymer paint and silkscreen ink on canvas

Printed in Hong Kong
10 9 8 7 6 5 4 3

Harry N. Abrams, Inc.
100 Fifth Avenue
New York, NY 10011
www.abramsbooks.com

Contents

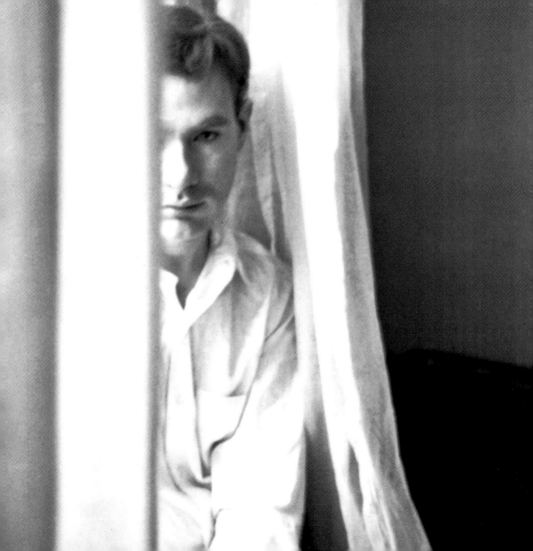

The Essential Andy

Andy Warhol (1928–1987), the man who put Campbell's Soup cans in museums and on a par with the *Mona Lisa*, **is one of the most controversial artists of the 20th century.** In looking at his quintessentially Pop Art—to be defined in a moment—you may find it hard not to feel a little *irked.* Why devote wall space to things you can see on a supermarket shelf? Where's the genius in reproducing a photograph of Marilyn Monroe 100 times? Why pay good money for a *picture* of a dollar bill? What's the point of a five-hour-long film of someone sleeping? In telling the story of Warhol's art in terms of his life and times, this book will show how relevant your questions are in understanding the significance and appreciating the essential *beauty* of Andy Warhol's provocative art.

Say What????

Beauty. Yes, that's right, **the beauty of Warhol's art.** You may ask, *Where's the beauty in a work of art that looks barely touched by a human hand?* Actually, Warhol's early Pop paintings are very handmade; he labored meticulously to

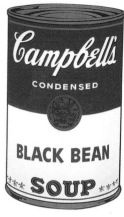

Tate Gallery, London/Art Resource, NY

ABOVE
Soup Can: Black Bean

OPPOSITE
Andy Warhol, 1958

5

copy reproductions of cartoons and cheap advertisements. And though the results may not reflect the kind of bravado brushwork one can so easily appreciate in, say, a painting by Vincent van Gogh, that's exactly the point. Pop artists strove to produce the cool look of mechanical reproduction. That's why Warhol soon abandoned the fussiness of a brush in favor of the slickness of silkscreening, a commercial technique he employed in creating a new beauty in art (see page 48).

OPPOSITE
Detail from
Ten Lizes, 1963
6'7 ¹/₈" x 18'6"
(201 x 564 cm)

Sound Byte:
"His art was an intentional provocation, of course, as almost everything he did was calculated to win attention."

—DAVID BOURDON, Warhol biographer, 1989

Though they appear mechanical, Warhol paintings and silkscreens involve the kind of formal decisions and pictorial problem-solving associated with the most conventional works of art. (After all, he did train as a painter.) He grappled with the same questions as all artists: Which images to reproduce? How to compose them? What scale would be most effective? Do I use color, and, if so, what colors?

Warhol deliberately edited and tweaked his images for maximum aesthetic impact. That's what makes them resonate in the mind's eye. Yesterday's tabloid photo of a gruesome car crash may be no more memorable than tomorrow's. But you will not soon forget Warhol's

Five Deaths (see page 63) or *Electric Chair* (see page 62). There's nothing casual about the surfaces of his paintings, either. Look carefully and you will see how subtle and various the nuanced effects are that Warhol obtained in his painterly reproductions. Take *Ten Lizes,* ten almost identical portraits of the actress Elizabeth Taylor, famously gorgeous since childhood (two of the ten are shown here). Without thinking about it, you respond to a Liz that is densely clogged with ink differently than you do to a Liz that is barely registered on the canvas and practically fading from sight. Beauty, with its emblems (such as movie stars, power, and fragility), is ever-present in Warhol's art.

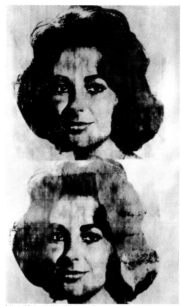

Musée National d'Art Moderne, Paris

Sound Byte:

"The metamorphosis accomplished by Pop artists like Warhol is great. They looked with warmth at supermarket wares. They exalted them and absorbed them into their glamorous paintings. For what is beautiful to the great artist becomes *beautiful."*

—DOMINQUE DE MENIL, arts patron, Houston, Texas

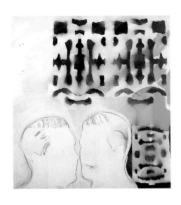

Heads, c. 1955
Mixed media on canvas
41 ¹/₂ x 39" (105 x 99 cm)

The Warhol Enigma

Was he a crafty charlatan who capitalized on sensation? Or was he a gifted artist who captured the spirit of an era? Was he an evil Svengali who corrupted youths with a wild milieu of sex, drugs, and rock-'n'-roll? Or was he an innovative entrepreneur who energized New York City's influential downtown scene?

Andy Warhol, the **Prince of Pop,** created the most sensational art of the 1960s. He appropriated images that Americans already knew and loved (or knew and feared)—Marilyn Monroe, Coca-Cola, the Empire State Building, dollar bills, Brillo boxes, the electric chair—and transformed them into radical and enduring works of art, simply through the act of reproduction. Using techniques of commercial printing, Warhol silkscreened paintings onto canvas by the yard and eventually turned some of them into wallpaper art!

Art was his **business,** his industry, and he called his New York studio **the Factory.** There, he employed a fashionable cast of young people to help him create his works. (Many others showed up to vie for available couch space.) Not limited to paintings, prints, and drawings, Warhol also produced record album covers,

books, magazines, dresses, films, performance events, television shows, and music videos. And any book that claims to articulate the *essential* Warhol (as this book does) must also include the proto-punk band he produced (The Velvet Underground), his X-rated movies (e.g., *The Chelsea Girls*), and his fashion fanzine (*Interview* magazine).

Sound Byte:
"I think somebody should be able to do all my paintings for me."
—ANDY WARHOL, *Art News,* November 1963

Behind Every Great Factory: An Even Greater Machine

We tend to picture Warhol as a passive presence, hovering in the background, while others created his art for him. But this was largely an illusion, one that Warhol worked hard to sustain. It suited his Pop persona *(uh…gee)* to appear remote and detached from artworks that were, themselves, impersonal looking. *It just wouldn't look right for an artist to toil and sweat over a silkscreen.* But, in fact, Warhol worked constantly—almost compulsively—and with great dedication and discipline to conceptualize, direct, and implement his vision. Assistants labored to keep up with the demand for his art by fabricating new productions. **But Warhol was the machine that drove the Factory.**

Sound Byte:

"Machines have less problems. I'd like to be a machine, wouldn't you?"

—ANDY WARHOL, *Time* magazine, 1963

The Warhol Package

OPPOSITE TOP
Vacuum Cleaner
1960
26 ⅝ x 39 ⅞"
(67.5 x 101 cm)

OPPOSITE
BOTTOM
*Fashion: Two
Female Torsos
with Necklaces*
c. 1983
20 x 32"
(51 x 81 cm)

Like any industrious entrepreneur, Warhol was ever on the lookout to express new ideas in his signature style. He was famous for asking his friends and colleagues what he should do next. His market research was on the order of "Do you think such-and-such is a good idea?" Indeed, Warhol was the consummate packager. He drew directly from Pop culture, contemporary art, and whatever else was current. This is an *essential point* to grasp: **Warhol's art is totally about culture.** Epitomizing 1960s Pop culture, Warhol's art packed:

- **the coolness of photography.** Slick and impersonal looking, his images appear easily reproduced, if not actually repetitive.

- **an infatuation with fame.** An avid fan of celebrity in any form, Warhol loved to depict the movie stars and name brands that America consumed.

- **sex and/or violence.** There's glamour in both, as Warhol showed.

- **graphic sophistication.** The strengths of Warhol's talent as an artist were his drawing and design.

If you think this sounds more like a recipe for an *effective advertising campaign* than the traditional aspirations of high art, then you're ready to start unraveling *the Warhol enigma.* Before he became a Pop artist, Andy Warhol had a booming career in graphic art and was among the highest-paid commercial illustrators in New York. In packaging himself, Warhol promoted an image of **innocent detachment** (though he was surrounded by sex and drugs, he rarely partook in them, other than diet-pill amphetamines), **articulate inarticulateness** (a master of understatement, he let others do the talking), and **effortless productivity** (art poured out of his studio, but he never broke a sweat). A closer look at the essential Warhol shows how deceiving appearances can be.

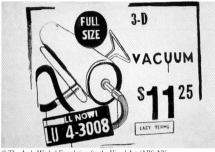

© The Andy Warhol Foundation for the Visual Arts/ARS, NY, Andy Warhol Museum, Pittsburgh, PA

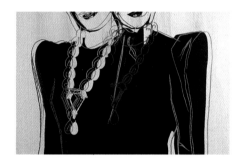

Sound Byte:
"Opinions, in the past, have differed wildly as to whether Warhol was a genius or a con artist extraordinaire."
—SISTER WENDY BECKETT, art historian, 1994

Thirty are better than one, 1963
110 x 94 ¹/₂"
(279 x 240 cm)

To Market, to Market, to Buy a...Warhol!!!!

Warhol's paintings seem to **contradict the conventional expectations** for a work of art—namely that **art is unique** (Warhols appear mass-produced), **visionary** (Warhols use preexisting images), **serious** (Warhols are noncommittal), meant to **convey emotion** (Warhols are cool); that art **rises above commerce** (Warhols are a business) and is **priceless** (Warhols come in small, medium, and large, priced accordingly). Art-historically speaking, these contradictions are the very essence of Pop, a movement that radically changed the look of things—of high culture, of pop culture, and even, according to Warhol, of America—and is a movement that Warhol's art has come to define.

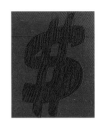

Dollar Sign, 1981
20 x 16"
(51 x 41 cm)

Sound Byte:
"Making money is art, and working is art, and good business is the best art."
—ANDY WARHOL, *THE Philosophy of Andy Warhol,* 1975

A Pop Primer

Pop is generally considered a reaction against Abstract Expressionism. As an expression of post–World War II optimism, it embraced the postwar commodity culture. Diametrically opposed to Abstract Expressionism, which featured unrecognizable abstract images

swirling all over the canvas, Pop Art delivered pictorial products you could name (big French fries with a blob of ketchup) and meanings you could read ("Whaam!"), all with a studied coolness. Pop came into being during a period of unprecedented economic prosperity—the 1960s—in which a growing number of people had money to burn in a world filled with things newly available to buy (cars, toasters, lunch meat, houses, shoes, televisions). The business that fueled this consumer economy—advertising—became an industry in itself and exploded into a social phenomenon in postwar America.

Sound Byte:
"Once you got Pop, you could never see a sign the same way again. And once you thought Pop, you could never see America the same way again."
—ANDY WARHOL, *POPism,* 1980

Media World

Starting in the 1960s—with television, newspapers, billboards, catalogues, magazines, and movies—everywhere you looked, words and images appeared to shape the desires they promised to fulfill, usually with a purchase. In the 1960s, Pop artists looked at this new landscape of signs and saw common forms of visual language that had the power to arrest and stimulate the imaginations of entire populations. (And now there's hardly a place left on earth where golden arches don't scream

McDonald's.) These Pop artists thought, *Why not grab that kind of communicative impact for art?* By embracing a commodity culture, Pop artists sought to:

- create ambitious works that transmitted artistic experiences as clearly, accessibly, and powerfully as advertisements and other familiar forms of popular culture.

- subvert accepted standards of quality and taste with shockingly banal images.

- emphasize the basic relationship between material goods and money—i.e., assert the notion that art is just another commodity.

Pop, American Style

Though it began in England, the movement took off independently in America, the nation that the Brits had already designated as Pop's Mecca, the place to turn for Coca-Cola, the car culture, Hollywood cinema, and capitalism. **Pop culture** can be defined as industrially produced forms of culture created on a mass scale as a commercial enterprise. *Examples:* advertising, comics, cartoons, magazines, movies, newspapers, pulp fiction, and product packaging.

BACKTRACK:
ABSTRACT EXPRESSIONISM
Peak period: Late 1940s–1950s
Key Players: Jackson Pollock (1912–1956); **Willem de Kooning** (1904–1997); **Mark Rothko** (1903–1970)
Names: Also called AbEx, Action Painting, and the New York School.
Subjects: Emotions, ideas, subjective realities, Existential struggles and angst, the sublime, and other epic abstractions.
Characteristics of painting: The canvas was regarded as a field for authenticating philosophical and emotional states of being in non-representational compositions of brushstrokes, drips, lines, and color. AbEx emphasized the creative process and the *physical act* of painting over the end product; it introduced monumental scale to envelop viewers in experiencing abstraction.
Audience Impact: Triumphant! Abstract Expressionism represented The Triumph of American Art. It made its protagonists internationally famous as Modern Masters and marked New York City as the new headquarters of contemporary culture—*the* place to see, make, and buy new art—a distinction previously held by Paris.

Pop didn't just pop out of nowhere. It grew out of a rich tradition with affinities throughout 20th-century art. Here are some of the essential movements and figures that precede Warhol's Pop Art:

DADA (French for *hobby-horse*): Anti-art movement that emerged in the wake of World War I, chiefly in Zürich and subsequently in New York City. It was characterized by anarchic and absurd gestures that mocked the sanctity of art, as when Dadaists cut up a magazine and randomly pulled words out of a hat to compose Dada poetry.

MARCEL DUCHAMP (1887–1968): French-born artist, central to New York Dada and to *soooo much* avant-garde art to follow. In 1914, Duchamp introduced the *readymade*, an everyday found object—such as the bicycle wheel shown here, or a urinal—presented as an original work of art. Exhibited in museums and galleries, readymades shifted attention from the art object (*What's to say about the textures, light, and composition of, say, a bottle-drying rack?*) to the system of conventions that can transform any object into a work of art. Duchamp was one of the first artists to focus on the conceptual nature of art: It's a work of art because an artist says it is; because it occupies the place of art (a wall, a pedestal, a museum); because it's worth so much money; and because you perceive it to be art (*hey, the label says so*).

SURREALISM (*Sur* is French for "on" or "above"): An evolution of Dada and the predominant movement in European art during the 1930s and 1940s. Inspired by the way cartoons, cinema, fashion, and advertising (yes, popular art) could interject elements of fantasy into the landscape of everyday life, the

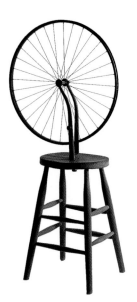

Marcel Duchamp
Bicycle Wheel, 1963

© 1999 Artists Rights Society (ARS)
New York/ADAGP, Paris/The Estate of
Marcel Duchamp. Coll. Richard Hamilton
Henley-on-Thames, Great Britain
Cameraphoto/Art Resource, NY

Surrealists aimed to make art that presented the irrational imagery of dreams as forms of common experience.

DISPLACEMENT: A key strategy shared by Pop artists and their predecessors. *Displacement* is the act of taking something (an object, an action, a picture) from a nonart context (where it performs a certain function) and sticking it into an art context (where it becomes something to be looked at). Through displacement, a familiar object can appear mysterious and disturbing.

PROTO-POP: Emerged during the mid-1950s and is sometimes referred to as Neo-Dada. Seeking alternatives to the pure gestural painting of AbEx, this art was marked by a cooler touch and deadpan humor. Among those setting the stage for Pop were:

Jasper Johns (b. 1930): In 1954, Johns made his first in a series of paintings of the American flag, entitled *Flag*. The surfaces of these paintings are rich with brush marks; the imagery is pure stars and stripes. *(So, is it a flag or a painting?)* Johns, who also depicted beer cans, light bulbs, numbers, alphabets, maps, and targets, encouraged a view of art as something ordinary or familiar. Philosophically and artistically, he claimed that pre-existing images allowed him to concentrate on "other levels."

Robert Rauschenberg (b. 1925): Introduced the *combine* in 1954. Part painting, part sculpture, these collages—or combinations—of found and created objects (newspapers, photographs, stuffed chickens, drawing, painting, shoes, a mattress, you name it...) realized the artist's ambition to make art as visually diverse an experience as walking down a city street.

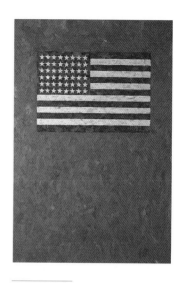

Jasper Johns
Flag on Orange Field, 1957
Encaustic on canvas
66 x 49" (167.6 x 124.5 cm)

Museum Ludwig, Ludwig Donation, Cologne
© Jasper Johns/Licensed by VAGA, New York, NY
Giraudon/Art Resource, NY

Pop Beyond the Pale

Even though Warhol's art is contemporary, there are aspects of it that go back in history to **Medieval Christian art,** both Western and Byzantine, when saints and icons were the superstars and brand names of the day (recall St. Ursula, that *awesome* girl who went to sea with 11,000 other virgins to prove her faith); to **Renaissance art,** when it was traditional for a successful artist to oversee a workshop of assistants, all trained to emulate his technique in order to keep business bustling; and to **Baroque art,** when still-life paintings teemed with expensive flowers, human skulls, decomposing fruit, and other unsavory reminders that beauty fades, fortunes change, and mortals eventually die.

Such connections help to demonstrate why Warhol's art endures. But how did Andy Warhol get famous in the first place? *And why is he considered so important?*

The Importance of Being Andy

Self-Portrait, 1978
Screenprint
41 ³/₄ x 29 ³/₄"
(106 x 76 cm)

Warhol himself neither offered nor refuted any explanation of his work. Indeed, his favorite response to commentary of any sort seems to have been a blank stare and a soft, *Uh...Gee...Great...Wow....* Believe it or not, therein lies a clue to his importance: Warhol made it possible—and very cool—for artists to be enigmatic in relation to the meaning of their art. Look deeply into Warhol's oeuvre for clues to the following:

- **Where's the conviction?** Did he love the celebrities he idolized in his work? Or was he just reflecting the culture's infatuation with fame? *Answer: Uh....*

- **Where's the compassion?** Did he mourn Marilyn Monroe's tragic life? Or was he simply fascinated, like the rest of the world, by the death of a star? *Answer: Gee....*

- **Where's the critique?** Was Campbell's Soup really his favorite brand of canned soup? Or simply the best-advertised, most famous one? *Answer: Great....*

- **Where's the condemnation?** Were his silkscreened paintings of race riots a form of political protest? Or just images taken off the news? *Answer: Wow....*

The profoundly disturbing and significant fact is that there is no difference between illusion (image) and reality (substance) in Warhol's art. Almost from day one, the most common metaphor used to describe Warhol and his art has been that of a **mirror.** *Like a mirror, the artist offers no judgments. Like a mirror, Warhol's art is a perfect reflection.* There's nothing beyond, beneath, or behind. Surface and subject merge into one. And that, in short, is Warhol's achievement. At precisely the moment when images begin to have currency, when the nation's industrial society gives rise to a consumer culture, when, through advertising, television, and other media, a person's *looks* begin

to have more substance than one's meanings or actions, Andy Warhol makes it his business to produce art that is nothing but **pure, absolute image.** So, you're thinking, *If Warhol's art essentially adds up to this great big nothing, why isn't the rest of this book blank?* Read on and you'll find out why.

Sound Byte:

"If you want to know all about Andy Warhol, just look at the surface of my paintings and films and me, and there I am. There's nothing behind it."

—ANDY WARHOL, 1967

An American Boyhood: 1928–45

Andrew Warhola (with an "a") is born in Pittsburgh, Pennsylvania, on August 6, 1928, the youngest of three boys, to immigrant parents from Czechoslovakia. Devoutly religious, the Warholas raise their children in the Catholic faith, regularly attending church. Andy grows up in South Oakland, a working-class Pittsburgh neighborhood populated by many Eastern European immigrants. His father, **Ondrej Andrew Warhola** (1888–1942), earns a decent living as a construction worker who travels routinely for his job. His mother, **Julia Zavacky Warhola** (1892–1972), is devoted to the baby of the family. (Andy's brother **Paul Warhola** is born on June 26, 1922; his brother **John Warhola,** on

May 31, 1925.) Warhol remembers Julia's reading the **comics** to him in her nearly incomprehensible English—a language she never fully commands and always pronounces with a thick accent—and rewarding him with **candy bars** whenever he completes a page in his **coloring books.** (Here marks the inception of Warhol's lifelong passions for chocolate and coloring.) Julia loves to have the kids sit around the kitchen table and draw. From an early age, Andy displays talent.

Andy's Mother

Julia Warhola is a major factor in Andy's life, nurturing his creativity with:

Julia Warhola
c. 1957

- **A folk artist's talent.** She decorates Easter eggs in the Slovakian tradition, and later turns her hand to a quirky style of calligraphy. It is Julia who does the lettering for Warhol's commercial art of the 1950s. *In 1959, she receives an award from the American Institute of Graphic Arts dedicated to "Andy Warhol's Mother."*

- **His first movie projector.** She takes on domestic work to buy her eight-year-old the object of his desire for home screenings of cartoons and other short subjects.

- **Entrepreneurial enterprise.** To augment the family's income, Julia fashions decorative flowers out of empty food cans and crêpe paper and sells them door-to-door. (Some critics have speculated that

these frugal blossoms were harbingers of Pop Art to come.)

- **Mothering.** Julia moves to New York City in 1952, where she lives with Andy (and cats) until 1971, first in his apartment at 242 Lexington Avenue, then at 1342 Lexington Avenue.

Sound Byte:
"He asks me... 'Mom, what shall I do, what shall I do now?' and I tell him, 'Andy, just believe in destiny, you will get it in a dream and then you will go off and you will do something great, crazy, terrific.'"

—JULIA WARHOLA, on her son's youthful ambition

Superman and Shirley Temple

OPPOSITE
*Myths
(Superman)*
1981. One from
a portfolio of
ten screenprints
and colophon
printed on Lenox
Museum Board
38 x 38"
(97 x 97 cm)

When he is about nine, Andy contracts chorea (also called St. Vitus's dance), a nervous disorder marked by spasmodic movements and facial tics. Strangely, his skin loses pigment and some will think him albino. The illness keeps him housebound for over two months and reinforces an already introverted disposition. Never sporty, Warhol cultivates interests that will blossom into many of his adult predilections. Besides chocolate, films, Superman comics, and coloring, Andy has a penchant for taking snapshots with the family Kodak, and idolizing celebrities. Warhol's first big collecting coup—an autographed photo of Shirley Temple—remains a lifelong treasure.

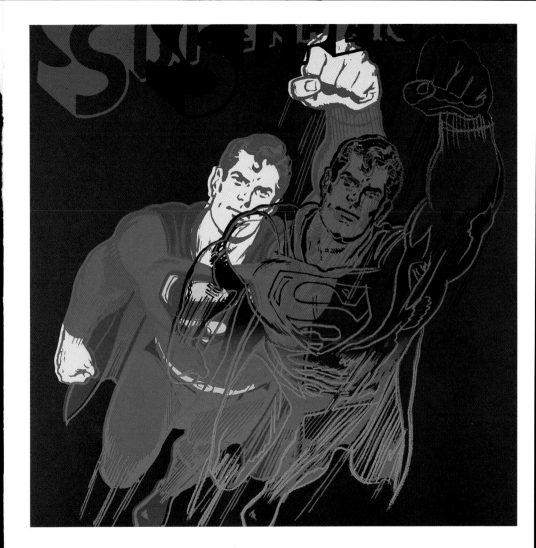

Peak period: 1960s

Key players and their brand-name items: Roy Lichtenstein (1923–1997) and his paintings of comic strips, such as *Whaam!;* **Claes Oldenburg** (b. 1929) and his sculptures of giant fast-food items; **James Rosenquist** (b. 1933) and his paintings on the scale and in the style of billboards; **Andy Warhol** and his paintings and silkscreen prints of name brands and famous faces.

Subjects: Images and objects from everyday life, popular culture, and the media (advertising, film, newspaper).

Style: Mechanical, depersonalized, quasi-photographic, Pop emulates or directly employs techniques of commercial printing and manufacturing. The Pop palette is artificial. Colors are applied in flat layers with hard edges.

Characteristics of Pop: Artists reproduced the commodities and signs of material culture to create pictorial products that had a field day with the tradi-tional distinctions between high and low culture, good and bad taste, art and commerce. Pop artists found excellent sources for the stuff of contemporary art in Hollywood (entertainment), New York (the art world), Madison Avenue (the advertising industry), the airwaves (television), and virtually any store (products and packages).

Audience impact: Massive and instant. Pop Art was accessible, playful, sexy, ironic, and stylish. It mingled directly with life. Collectors bought it, museums exhibited it, the media covered it, and a lot of critics and non-Pop artists hated it—but hey, the public loved it!

Who put the "Pop" in Pop Art? Some say it started with a Tootsie Pop, the one that British artist **Richard Hamilton** glued—with a magazine pin-up, comic book cover, Ford emblem, and bodybuilding ad—into his 1956 collage

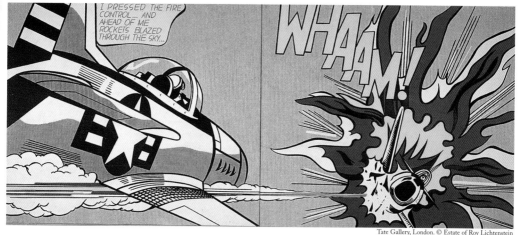

Tate Gallery, London. © Estate of Roy Lichtenstein

Just What Is It That Makes Today's Home So Different, So Appealing? It may surprise you that Pop originated in Britain, but in the mid-1950s, artist Hamilton, along with critics **Lawrence Alloway** and **Reyner Banham**, proclaimed their interest in industrial, or popular, culture. Alloway, who actually coined the term, was the first to use Pop in print in a 1958 essay for *Architectural Digest*.

Roy Lichtenstein
Whaam! 1963

Sound Byte:

"We felt none of the dislike of commercial culture that was standard among most intellectuals, but accepted it as fact, discussed it in detail, and consumed it enthusiastically."

—LAWRENCE ALLOWAY, critic, on the thinking behind Pop

Educating Andy

As a member of the Tam-o'-Shanter Club, Andy is one of Pittsburgh's children selected to receive free Saturday art classes at the Carnegie Institute of Technology (now Carnegie-Mellon University). At the end of each session, when honor roll is called, Andy is often named. In 1942, when Andy is 13, his father dies, leaving money earmarked for his son's education. He skips 11th grade and graduates from high school with the yearbook epithet "As genuine as a finger print." In 1945, he enrolls in the Department of Painting and Design at the Carnegie Institute, a program that stresses art's practical applications (and getting a job) over individual expression (and starving in a garret).

Despite his facile talent, Warhol has difficulty in school. He fails a class in perspective and is practically kicked out, but redeems himself by attending a summer session. He wins a school prize for drawings done spontaneously from life, while minding his brother's fruit truck, then distinguishes himself as a scholarship student by creating shocking interpretations of assignments. To illustrate the final scene of a Willa Cather short story, while his classmates render trains, bridges, and the hero's suicidal leap, Andy produces a red splat, showing the bloody impact caused by the on-rushing locomotive. *For a self-portrait study, he depicts himself as a girl.* One instructor deems him least likely to succeed; another calls his work the most promising commodity he has ever seen.

Student Profile

In college, Warhol's boyish personality makes him seem even younger than his 15 years. Shy to the point of near nonverbalness, he fails a required course called "Thought and Expression." Not to say he isn't social. He sets up studio with four other classmates in an old carriage house (premonitions of the Factory?) and is generally admired by his peers, who call him by his own nickname "André."

Blotting a Course to Success

Throughout college, Warhol compensates for a disinclination toward academic subjects and conventional art training (perspective) with his original approach and highly sophisticated sense of design. The November 1948 issue of his school magazine features a cover by Warhol, who is art editor in his senior year. The cartoony platoon of violin players may be the first published example of Warhol's key to success as a commercial artist: *the blotted line technique.* Warhol invents this drawing technique to suit his witty style. It produces a fragmentary line, erratically blobbed with ink. *How does he do it?* Make a drawing in pencil. Go over it in ink, and while the ink is still drying, press down with another piece of paper. Voilà: The blotted impression you lift up is *the new original.*

Detail of fashion illustration showing blotted line technique 1953. 9 $^{9}/_{16}$ x 5 $^{15}/_{16}$" (25.40 x 15.25 cm)

Well, Not *Entirely* Original

Warhol's blotted line has its origins in another artist's broken line—namely, the distinctive drawing technique of Lithuanian-born U.S. painter **Ben Shahn** (1898–1969). Famous during the 1940s as both a commercial and a fine artist, Shahn is an early influence on Warhol, for whom Shahn represents art-world celebrity. (While Warhol is in college in 1947, The Museum of Modern Art in New York gives Shahn a one-person show.)

Pick of the Class

During college, Warhol spends one summer working in the display department of a Pittsburgh department store. It is a revelation of **the fashion world** (Warhol hears a siren call while pouring over the pages of *Vogue* and *Harper's Bazaar,* filled with elegant and witty graphic art) and of **life beyond Pittsburgh** (he later said he idolized his boss, Mr. Vollmer, "because he came from New York and that seemed so exciting").

Warhol's college career ends and **his professional life begins on a moment of controversy.** To the prestigious 39th annual exhibition of Pittsburgh artists, typically a showcase for Carnegie Techies, he submits a monstrously rendered painting of a face with a finger shoved deeply into one giant nostril. The first juror instantly rejects *The Broad Gave Me My Face, But I Can Pick My Own Nose* as **repulsive;** the

second (none other than the internationally renowned German artist **George Grosz**, 1893–1959) argues that it's great; the third breaks the tie with a vote of dissent. However, Warhol gets the last laugh when, a few months later, in time for his college graduation, he exhibits the rejected work in a local group show. People flock to see the infamous painting, now pointedly retitled *Why Pick on Me?*

New York Calling: 1949

In the summer of 1949, he moves to new York with another Pittsburgher, **Philip Pearstein** (b. 1924), a painter. Warhol gets his first commercial job—illustrating a story for *Glamour* magazine entitled "What Is Success?" Warhol's blotted line submissions are an instant success and he is soon in demand as a **hot young talent** by art editors throughout the fashion and advertising worlds. Within a year, Andrew Warhola drops the "a" from his name and begins signing his work Andy Warhol.

Sound Byte:
"I greeted a pale, blotchy boy, diffident almost to the point of disappearance but somehow immediately and immensely appealing. His ink lines were electrifying. Fragmented, broken, and intriguing, they grabbed at you with their spontaneous intensity. Andy was so obviously talented I knew I wanted to use him."
—TINA S. FREDERICKS, art director at *Glamour* magazine and first Warhol employer

TECHNIQUES: From 1949 through the early 1960s, Warhol worked as an increasingly famous commercial illustrator. He became one of the highest-paid artists in the field and received many awards for his innovative work. His techniques—many of which carry over to Warhol's Pop Art—include:

- **Blotted line technique.** His graphic standard since college days, this technique didn't carry over, though its aesthetics of reproduction did.

- **Rubber stamps.** Starting in 1955, Warhol introduced the element of repetition by using hand-made stamps.

- **Photographic reproductions.** Starting in 1956, Warhol included photographic images, either traced or copied using a projector.

BUSINESS: To supply the demand, Warhol hired assistants (and employed his mother!) and turned his apartment into an industrious studio. In 1957, he formed **Andy Warhol Enterprises, Inc.** Under this umbrella he later produced films and publications.

STYLE: Quirky and quintessentially graphic, Warhol's work is all about line, about capturing the contours, the most elegant shape of a thing, and then adding those wrinkles that make it humorous, animated, and charming. Color is decorative (not representational) and is laid on in flat, unmodulated blocks or areas. Basically, this is Warhol's approach to color in all his art.

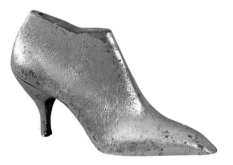

Untitled (Shoe), c. 1956. Gold leaf and silver leaf on wood. 5 x 8 ⁵/₈ x 2 ³/₄" (13 x 22 x 7 cm)

SHOES: What catapulted Warhol to graphic fame and fortune? In 1955, he captured the I. Miller shoe company account for weekly advertisements in *The New York Times*. His

charismatic drawings—each shoe radiated personality—resulted in an award-winning campaign. In 1957, *Life* magazine did a spread of Warhol's portraits of fantasy footwear inspired by famous men and women, from Elvis Presley to Zsa Zsa Gabor. Other clients included Tiffany & Co., fashion magazines galore, and Doubleday publishers, who hired him to create art for Amy Vanderbilt's *Complete Book of Etiquette* (1952).

GIFTS: Warhol showered his clients with little presents to remember him by: handmade books, edibles, Easter eggs decorated by his mother. *You're a busy art editor, but you're not gonna forget the guy who brings you, inside a paper bag, a Siamese kitten wearing a tiny turtleneck sweater.* The power of prezzies continued; in the early days of his art career, after a powerful dealer admired a painting in the studio, Warhol promptly sent it to him *gift-wrapped!*

WARHOL'S ILLUSTRATED BOOKS: During the 1950s, Warhol produced whimsical and exquisite illustrated books, including: *Love is a Pink Cake* (1953); *25 Cats Name Sam and One Blue Pussy* (1954) [Note: The grammar is

Andy's mother's]; and *Wild Raspberries* (1959), the latter being a cookbook (written with Suzie Frankfurt) full of culinary delights. Primarily intended as gifts for clients, the books were printed in limited editions and hand-colored at "coloring parties"—Warhol's clever way of getting pretty boys and friends to work for him while having a fun get-together.

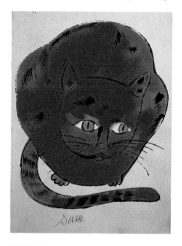

Untitled (Cat: "25 Cats Name Sam and One Blue Pussy"), c. 1954. Hand-colored offset print. 9 1/8 x 6" (23 x 15 cm)

Sound Byte:

"I loved working when I worked at commercial art and they told you what to do and how to do it and all you had to do was correct it and they'd say yes or no."

—ANDY WARHOL, *THE Philosophy of Andy Warhol*, 1975

Camp Serendipity

OPPOSITE
Truman Capote
1978
Polaroid print
4 ¹/₂ x 3 ³/₈"
(11.43 x 8.64 cm)

Before he becomes a famous Pop artist and while he is being a famous graphic artist, Warhol cultivates a major reputation in one of New York's subcultures: the uptown world of high-class camp. We're talking:

- **precious and sexy.** He makes gold-leafed drawings of beautiful boys and those classic fetish items—shoes—along with contour drawings of naked feet and a compendium of penis portraits.

- **decoration and decorative techniques.** Warhol makes ornamental screens, and covers wooden shoe forms in paint and collage. In 1954, he papers the walls and floor of a gallery with marbleized paper drawings.

- **Truman Capote** (1924–1984). The author of *Other Voices/Other Rooms* (1948), *Breakfast at Tiffany's* (1950), and *In Cold Blood* (1965), Capote wrote on themes of glamour, violence, and low-life identities. He also placed himself at the center of New York's high

society by cultivating the friendship of its most beautiful and wealthy grandes dames, whom he nicknamed his "swans." As Capote has his "swans," Warhol has his "pretties" (cute boys) and "beauties" (gorgeous girls); they were the uptown precursors of Warhol's downtown "superstars." Warhol's first solo exhibition, held in 1950, is a series of drawings inspired by Capote's writings. The author initially withholds his favor, but later the two become friends.

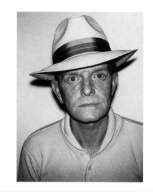

Sound Byte:
"When I first got to New York, I began writing short fan letters to [Truman Capote] and calling him on the phone every day until his mother told me to quit it."

—ANDY WARHOL, 1975

The headquarters of uptown camp is Serendipity, the ice-cream parlor/boutique located on East 58th Street (near Bloomingdale's as well as Warhol's apartment) that, at the time, attracts the fashion crowd and a gay clientele. Warhol loves their frozen hot chocolates and frequents the establishment often. He also exhibits and sells his work there, among other uptown venues.

A cultural sensibility expressed as a taste for artifice, excess, the queer, and the unnatural. **Camp** avoids deep content; it privileges glamour over beauty, the trivial over the important, the silly over the serious, the fleeting over the enduring. Because it goes so deliberately against the grain of conventional good taste and aesthetic morals, camp has often been associated with homosexuality. As a perverse form of elitism that takes rare pleasure in popular culture, it is also seen as reverse snobbism, or **modern dandyism.** Good examples of camp are: a gilded bouquet of plastic flowers, platform shoes, dressing in drag, divas, the films of John Waters, the aphorisms of Oscar Wilde, and Warhol's Pop persona.

Poor Little Rich Boy

By 1960, Warhol is a rich and famous commercial artist who can afford to buy a townhouse on Lexington Avenue—which he quickly fills with his copious **collections.** And yet he is not satisfied. In 1956, The Museum of Modern Art includes one of his shoe drawings in a group show. That same year, Warhol embarks on a world tour with a friend, to whom he announces a greater ambition: **He wants to be the next Henri Matisse.**

> *FYI:* **Warhol's collections**—Art Nouveau, Art Deco, American folk art, Native American art, costume jewelry, vending machines, jukeboxes, cookie jars, cosmetics.... Warhol is a compulsive shopper who stuffs each of his respective domains with acquisitions. He collects art, too—mostly his own work.

Entering the Pop Zone

Warhol crams three careers into one lifetime—as a **commercial artist** (1949–60), for which he earns a minor artistic reputation; a **Pop artist** (1960–68), for which he

Sound Byte:

"Here, one may compare Camp with much of Pop Art, which—when it is not just Camp—embodies an attitude that is related, but still very different. Pop Art is more flat and more dry, more serious, more detached, ultimately nihilistic."

—SUSAN SONTAG, cultural critic, in her definitive 1964 essay "Notes on Camp"

invents his machine and becomes famous; and a successful **business artist** (1968–87), in which he capitalizes on his celebrity.

It's 1960 and Warhol is 32. He has labored hard to establish himself, and despite his working-class origins, neurotic shyness, and oddball appearance, he has risen to the top of his profession as a commercial artist. Why on earth start all over again, trying to break into an entirely new career, particularly one as rigorous and exclusive as the contemporary art world?

What Makes Andy Run?

Judging from his commercial art career, the Warhol formula is already in place:

- **enormous creative energy.** Warhol is a tireless experimenter who relegates his signature work to assistants so that he can explore new

techniques, materials, and imageries, and can develop new products. *In 1960, this new product becomes an art career.*

- **visionary talent.** Warhol has an uncanny ability to envision the images that are most apt to shock, amuse, surprise, delight, offend, or satisfy any given client. *In 1960, the clients change from art directors to art dealers.*

- **sheer ambition.** Warhol studies painting. He collects contemporary art. And he's well aware of what will eternally elude him as a graphic artist. *In 1960, he sets out to command higher cultural value, along with the fame and fortune that accompany art-world celebrity.*

Sound Byte:
"Warhol later speculated that he and his friends were more productive during the 1960s because amphetamines provided them more 'awake time.'"
—DAVID BOURDON, Warhol biographer, on Warhol's diet-pill habit

Warhol, Pop Painter: 1960–64

Fasten your seat belt, because the next four years of Warhol's Pop Art career are about to *blast off*. But first, a quick perusal of what was going on in the New York art world in the early 1960s. Call it comparison shopping, product research, openness to new ideas, *Warhol was tireless*

THE NEW YORK ART SCENE, c. 1960

"Happenings": Since the late 1950s, *Happenings* attempted to make good on the Abstract Expressionists' claims that their paintings would surround viewers with fields of visual experience. Part theater, part fine-art environment, Happenings were relatively structureless events catalyzed by props, dialogue, or instructions. *(Hello, Warhol's Factory!)*

Dance and Performance Art: In 1963, Warhol started to attend events at Judson Chuch in Greenwich Village, where artists (including Rauschenberg and Jasper Johns) collaborated with dancers (such as Merce Cunningham). Works were characterized by routine movements and ordinary tasks, and a sense of endurance, boredom, and often untrained performers. *(Hello, Warhol superstars!)*

Minimalism: The austere and abstract counterpart to Pop, Minimalist art looked to industry and architecture for its materials (aluminum, lead, fluorescent lights) and forms (boxes, cars, bunkers). As a collector, Warhol owned work by his Minimalist peers, including a set of paintings by **Frank Stella** (b. 1936), each done in a different color of Benjamin Moore house paint and titled accordingly. *(Hello, Warhol Paint-by-Number paintings!)* and a small sculpture by **John Chamberlain** (b. 1927) made of crushed car parts. *(Hello, Warhol Disaster paintings!)*

Underground Cinema: Independent filmmaking flourished in New York during the 1960s. Although it was associated with raw politics, amateur performers, nudity, homosexuality, low budgets, experimental technique, and nonlinear narratives, it was actually the marginality of its production, vision, and venues that distinguished underground cinema. *(Hello, Warhol films!)*

The Store: A Happening by Claes Oldenburg (b. 1929), who opened his Lower East Side studio to display and sell his sculptures (of such things as pies and pantyhose) just like items in a department store. A 1961 visit to *The Store* excited Warhol so much that he became depressed. *(Hello, competition!)*

when it came to covering the scene. He went to readings, performances, and exhibitions; he made studio visits to see what other artists were doing. It's **how he got his ideas,** Warhol frankly told friends.

Don't Forget to Drip

In 1960, Warhol makes his first ambitious works on canvas. The images are taken directly from the funny papers and cheesy advertising (like you see in comic books or supermarket tabloids): Batman, Superman, nefarious nose jobs, unappealing toe treatments, canned peaches, sale prices, wigs, cosmetics. (The bodily references strike close to home given that "Andy, the red-nosed Warhola," as he was affectionately known as a child, was a man with a nose job, skin peels, light makeup designed to make him look pale, and a wig—he collected and

Some of Andy's wigs on display at The Andy Warhol Museum Pittsburgh

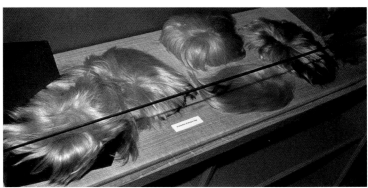

Founding Collection, Contribution The Andy Warhol Foundation for the Visual Arts, Inc. Photo: Matt Wrbican

wore gray, silver, and white wigs throughout his life.) Once he found his images, Warhol enlarged and transferred them onto the canvas with the assistance of an overhead projector. His painted reproductions are only quasi-faithful to the originals, in that they render the latter as fragments, with entire areas dropped out or abruptly chopped off.

But always, **there are drips.** Drips are clichés of Abstract Expressionism. Abandoning himself to the creative moment, Jackson Pollock had dripped and poured his paint straight out of the bucket. In contrast, Warhol's drips appear fastidiously drawn, studied, even decorative. They signal that *painting is going on here.* At the same time they say, *But let's not get too worked up about it, guys, it's just a bunch of kitsch.* Want to outrage an Abstract Expressionist? Call his work *kitsch* (a German word, used to describe and often denigrate a cheap sentimentality of pop culture). Warhol was only indirectly commenting on Abstract Expressionism; his more immediate targets—to whom he hoped to ingratiate himself through emulation—were Johns and Rauschenberg. Their Proto-Pop Art of the late 1950s—with its limpid drips, banal imagery, and actual newspapers collaged onto the surfaces—had already established a cool new temperament for painting.

Product Placement

Now that he has the product, Warhol needs a venue to exhibit and sell his hand-painted Pop. As a collector, he is already familiar with the

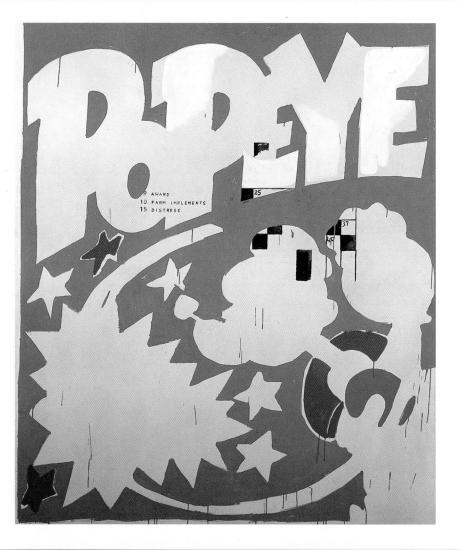

POPEYE, 1961
68 ¹/₄ x 58 ¹/₂" (173 x 149 cm)

What: A frame from a Popeye comic strip—*sort of.*

Huh? Why is Popeye such a ghost? And what's with those bits of floating crossword puzzle on his cap and fist? *Bad day at the printing press?* Warhol's hand-painted Pop images are composed to playfully reinforce their artificiality. (There's Pop even in the name "Popeye.") The images weren't abstracted from the artist's inner life; they were simply cut, spliced, and casually reproduced from everyday life.

How created: By hand. Using an overhead projector, Warhol transferred and enlarged the comic onto the canvas. He then meticulously painted the surface, coloring-book style. Neither totally neat nor completely sloppy, the surface is an odd mix of brushwork (traditional painting) and flatness (reproduction). The real teasers, however, are the **drips.**

Tidy-messy: As self-conscious as a stage debut, the drips in Warhol's early paintings announce, *Hello, we're really painting now!* and point to Warhol's crossover ambition. They also constitute a wave to Johns and Rauschenberg, whose Proto-Pop Art had already made a convention of the staged drip, their way of saying *adios* to the authentic gestures of Abstract Expressionism.

Nostalgia: Here's the thing about Pop Art images: *Many of them aren't as contemporary as they're cracked up to be.* In 1961, Popeye was already an old-fashioned cartoon character from Warhol's childhood during the 1930s.

Cool thing to know: Warhol handpainted more than one "Popeye." Another was among the first five canvases he ever exhibited; it was in one of his 1961 window displays for the Bonwit Teller department store!

Ivan Karp
at the Factory
1964

New York gallery scene. So, one day in 1961, while he's shopping at the **Leo Castelli Gallery,** buying himself a Jasper Johns *Light Bulb* drawing, he asks to see what else is interesting. Gallery assistant **Ivan Karp** pulls out a painting by then-unknown artist **Roy Lichtenstein.** It's an illustration of a girl in a bathing suit, taken from an advertisement. Warhol (whose pallor is naturally blanched) gulps. He tells Karp that he's been doing something similar and invites him for a visit. At the studio, Karp admires Warhol's paintings (Warhol gives him one as a gift), but the dealer says that he can't really do anything for Warhol at Castelli, since they've just committed to Lichtenstein. Karp also observes that Warhol's painting style equivocates between Expressionist gestures and stark reproduction, and he advises Warhol to concentrate on the latter. Warhol accepts the advice, as is apparent from his next absolutely **inexpressive** work: *silkscreen paintings of Campbell's Soup cans.*

Warhol's Pop Persona

Around the time of Karp's visit, Warhol reinvents himself. All signs of his (still thriving) commercial establishment go out of the parlor, which he now uses as a painting studio. To set a properly youthful tone (since new art can't be made by a campy old graphic artist), he plays teeny-bopper music, usually just one record that repeats itself ad nauseam. Other affectations include his adoption of an increasingly vapid attitude *(Gee, Wow, Great)* and his habit of wearing **masks.**

Sound Byte:

"He had bunches of [masks], and he made other people wear them as well. I don't think he was comfortable with the way he looked.... The mask gave him a more stylized look."

—IVAN KARP, art dealer recalling an early visit to Warhol's studio

The Soup Man Cometh

At the time Warhol chooses to concentrate on Campbell's Soup, it is America's canned soup of choice (four out of every five cans served). Campbell's Soup is as instantly recognizable as Warhol himself hopes to become, and does, in fact, make Andy Warhol a **brand-name Pop artist.** Here are the essentials:

- **First soup:** *Campbell's Soup can (Tomato Rice),* 1960, generally relates to his other (drippy) hand-painted Pop designs of supermarket product imagery, of well-stocked refrigerators, of Del Monte peaches, etc.

- **Serial soup:** In 1962, after polling his friends, Warhol elects Campbell's Soup as the perfect vehicle to distinguish his new Pop style, in which the *arty drips* are replaced with *mechanical repetition.*

- **Assembly-line production:** Warhol reproduces the overall **packaged look** of Campbell's Soup, not the actual details of the cans

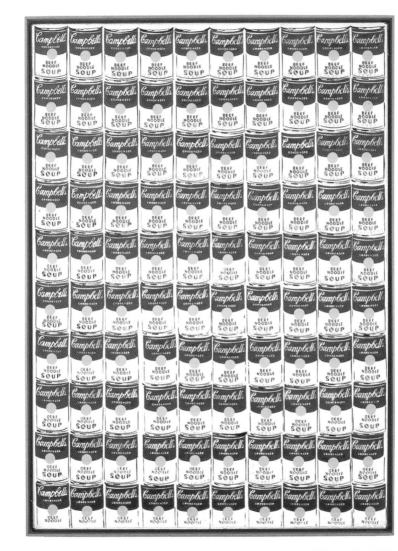

themselves. He removes all superfluous details—the ornate gold medallion becomes a bold yellow dot, and the fine print disappears—to make one big label.

OPPOSITE
One Hundred Cans, 1962
Oil on canvas
72 x 52"
(183 x 132 cm)

- **Stencils:** There are 32 varieties of Campbell's Soup at the time, and Warhol sets out to paint them all. To facilitate his work—that is, to maintain the desired uniformity and to avoid spending ten years making the images—he uses **hand-cut stencils** *in conjunction with painting,* and the result looks brushless.

- **Variety:** Warhol produces **a wide variety** of Campbell's Soup cans in the form of paintings and drawings, ranging from **single** soup cans to **pairs** to what appear to be **shelves** stocked with can after can of Campbell's. Most intriguing is a subset of images, showing the cans violated: labels ripped; cans naked, or even emptied and squashed.

- **Consumer report:** Word travels quickly that Andy Warhol is making soup into art. Even before they leave his studio, these paintings cause a sensational scandal. In other words, they are his first (calculated) success!

- **Art gallery into supermarket:** Warhol makes his Pop debut at the Ferus Gallery in Los Angeles with a solo show of soup-can paintings. As a joke, the neighboring gallery puts some **real Campbell's Soup cans** in the window, advertising five for one dollar.

Gearing Up for High Production

The year 1962 is a very good one for Andy Warhol, who speeds along in his production with:

- **technical experimentation.** In his desire to become more mechanical, Warhol experiments with **rubber stamps** *(S & H Green Stamps)* and **hand-cut silkscreens** (to reproduce his drawings of *dollar bills*) before he arrives at what will become his classic technique: **photo-silkscreening.** (His first product is *Baseball,* featuring Roger Maris—repeatedly!)

- **celebrities and disaster.** Warhol starts depicting **movie stars** (Troy Donahue, Elizabeth Taylor, Marilyn Monroe) and **death,** as in *129 Die in Jet (Plane Crash).*

Command Performance

Henry Geldzahler
1963

On June 4, 1962, Warhol gets the idea of painting *129 Die in Jet* from his friend **Henry Geldzahler** (1935–1994), curator of 20th-century art at The Metropolitan Museum of Art in New York. The two are sitting in Serendipity and Geldzahler announces that it's time for Warhol to paint something more serious than soup cans—like **death,** for instance. Warhol has already done some paintings of the front pages of newspapers, so Geldzahler hands him a copy of *The New York Mirror,* splashed with a plane crash, and suggests he paint that. Warhol does.

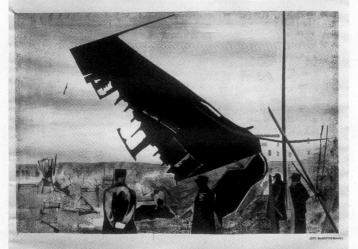

*129 Die in Jet
(Plane Crash)*
1962. 8'4" x 6'
(254 x 183 cm)

SILKSCREENING

Also called *serigraphy*, this is a form of mechanical reproduction developed in the early 20th century for the commercial textile industry. Pigment is forced through hand-cut or photographically stenciled screens that block or allow ink to pass through onto paper. Factory assistant Gerard Malanga explains that "Andy and I would lay the screen down on the canvas, trying to line up the registration with the marks we'd made where the screen would go. Then oil-based paint was poured into a corner of the screen's frame, and I would push the paint across the mesh surface with a squeegee…. We'd lift the screen, and I would swing it away from the painting and start cleaning it with paper towels soaked in a solution called Varnolene. If this was not done immediately, the remaining paint would cake up and clog the pores." (*Working with Warhol*, 1997)

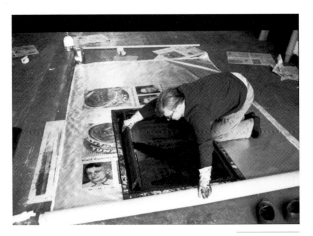

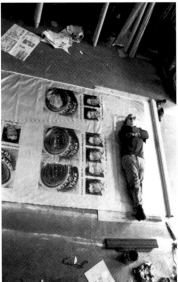

ABOVE AND RIGHT
Andy silkscreening *Tuna Fish Disaster*
at the Factory, 1963

OPPOSITE
Tuna Fish Disaster, 1963
53 ¹/₂ x 70" (136 x 178 cm)

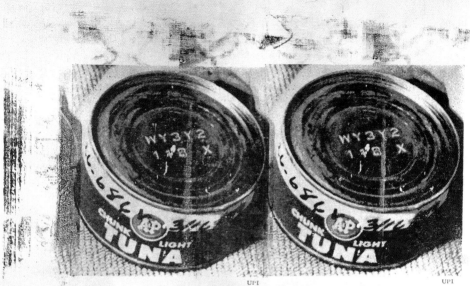

UPI

Seized shipment: Did a leak kill . . UPI Seized shipment: Did a leak kill . . .

The crash scene is one of the few images that Warhol paints *by hand* to represent a photograph. Truth-is-stranger-than-fiction: Six years later, to the day, Warhol himself makes the tabloid front pages....

Sound Byte:

"In the future, everyone will be world famous for 15 minutes."
—ANDY WARHOL, *THE Philosophy of Andy Warhol*, 1975

FYI: **Space Time**—Remember how Warhol failed his college class in perspective? Well, he didn't really need that stuff, because ultimately he created a new kind of space in his art. It was the space of *real time* passing. You don't look deeply into a Warhol and enter a space frozen in time. You scan a surface of a floating image, flickering light and shadow, variations and repetitions—and time ticks by.

Wish Fulfillment

By 1962, Warhol worries that fame will pass him by. All of the other artists who will be affiliated with Pop have shows lined up in New York. Warhol knows that if he doesn't get picked up soon, he's going to miss the boat. Suddenly, his all-consuming need is fulfilled when he scores solo shows in Los Angeles and New York and is included in a history-making group show. **The New Realists,** held at the Sidney

Janis Gallery in New York (November 1962) is important because:

- **It officially announces that Pop has arrived.** This respected gallery is associated with Abstract Expressionism and excellence.

- **It presents Pop as a major international movement.** Key figures of American Pop are shown alongside artists from England, Italy, Sweden, and France.

- **It is a scandal.** Outraged by what they perceive as a flagrant display of *kitsch*, all of Janis's premier artists—except for Willem de Kooning—quit the gallery.

Sound Byte:
"[The New Realists show] was an implicit proclamation that the New had arrived and that it was time for all the old fogies to pack it in."
 —THOMAS B. HESS, art critic reviewing Pop's breakthrough show

> *FYI:* **Warhol's Drawings**—During the early 1960s, Warhol made wonderful drawings that related directly to his paintings. He also drew pages from 1930s Hollywood magazines featuring glamour girls of the day and tabloid newspaper pages. He loved the way the latter leveled major events and gossip to the same **trashy** format. Throughout, the artist's handling varied from elegant, loose lines to crude, graffiti-style drawing.

MARILYN DIPTYCH, 1962
Two panels, each 82 x 57" (208 x 145 cm)
The Tate Gallery, London/ Art Resource, NY

What: 100 portraits of Hollywood's most glamorous star.

How: A publicity photo of Marilyn Monroe, cropped below the chin, and reproduced repetitively using a silkscreen.

When: The day after the closing of Warhol's exhibition of Campbell's Soup can paintings on August 4th at the Ferus Gallery in Los Angeles, Marilyn Monroe was found dead at her home in Los Angeles. Warhol began work on his series a few days later.

Cinematic beauty: Monroe's face appears ephemeral, rendered in the form of light and shadows, as if it were *projected onto a screen*. The composition even looks like *strips of film*.

Mechanical genius: Warhol moved quickly, accepting accidents of registration, greater or lesser amounts of ink, streaks, and blanks. His mechanical technique represents the mechanisms of fame, which *isolated* Monroe from the rest of humanity, *immortalized* her as a star, then consumed and *destroyed* her as a person.

Makeup artist: Half of the Marilyns appear to be wearing makeup, but it's really the makeup that is wearing *them*. Warhol first mapped out the colors, exaggerating these areas to ensure coverage when he silkscreened the face on top. The results are part drag queen, part death mask, with cosmetics bleeding over eyes, lips, and hair.

Saint Marilyn: Warhol made a variety of Marilyns. Some are on gold backgrounds. These highly camp renditions are reminiscent of his gold-leaf drawings of the 1950s; they also suggest Byzantine icons of Christian saints, illuminated in real gold. Did Warhol worship Marilyn Monroe—or her fame? Answer: *Uh....*

Cool thing to know: In 1964, a woman walked into the Factory, pulled out a gun, and shot a stack of Warhol's *Marilyns*. The repaired paintings are called Warhol's *Shot Marilyns*.

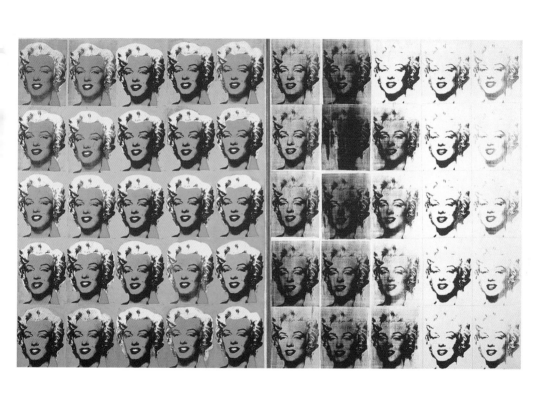

De-camping to Set Up Factory: 1963

Gerard Malanga
Andy's Factory
assistant, 1969

Early in 1963, Warhol moves his painting studio out of his parlor and into an abandoned firehouse on East 87th Street. The place has **no telephone,** and after a productive couple of months during which he works quietly on *Liz* and *Elvis* silkscreens with his new assistant, **Gerard Malanga,** Warhol moves again, this time to an industrial loft on East 47th Street. It has a **pay phone,** mercifully, because the space is instantly filled with bohemians, drag queens, socialites, the occasional star *(there goes Bob Dylan),* college students, drug addicts, art collectors, and the like—and the phone bills would otherwise be *out of control.* Everything is covered in silver foil and spray-painted silver, and Warhol dubs the space **the Factory** in honor of the day-and-night activity, which includes (almost incidentally) the production of his art. Assistant **Billy Name** moves around in a constant flurry of activity to keep everything looking nice and silver while a nameless cast takes turns on the maroon couch. Gerard Malanga swipes ink through silkscreens while Warhol films with his new 16-mm Bolex movie camera, and opera music blares in the background. *The whole place is a nonstop Happening.*

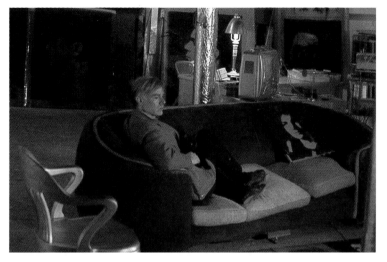

LEFT
Andy on the
infamous maroon
sofa, 1967

OVERLEAF
Elvis I & II
1964. Two
panels, each
82 x 82"
(208 x 208 cm)

California, Here They Come!

In the fall of 1963, Warhol and three companions drive cross-country
to attend the opening of his second exhibition at the Ferus Gallery in
Los Angeles. It is a total trip for Warhol who *(when he isn't stressing
out because the driver might fall asleep at the wheel)* relishes mile after
mile of **Pop paradise.** The art has been sent to California in advance—
images of Elizabeth Taylor and Elvis Presley, some on silver-screened
backgrounds. It's a real Hollywood show. And it causes some conster-
nation on the receiving end, where rolls of silkscreened canvas arrive

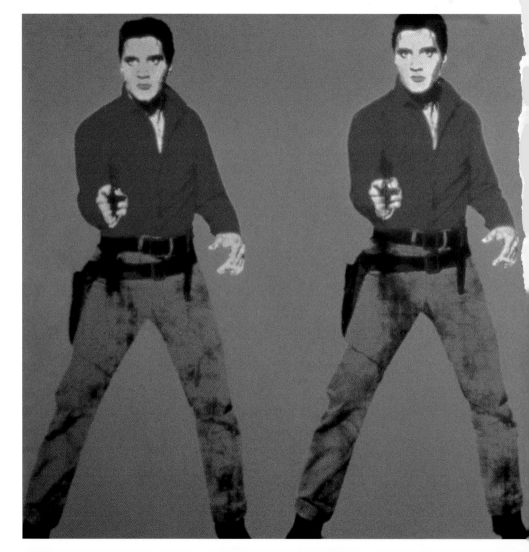

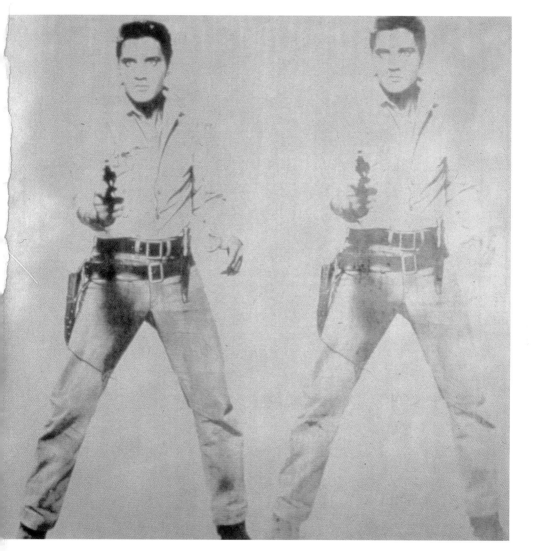

THE FACTORY: A WHO'S WHO

Brigid Berlin (aka Brigid Polk): Superstar. Dropout daughter of a rich family who became Warhol's entertaining Scheherazade; he loved her eccentrically funny gab. Her screen name, Polk, was an alleged play on her having "poked" her rear with needles of amphetamines in the movie *Chelsea Girls*. A conceptual artist, she now enjoys shopping and walking her pugs in the streets of New York City.

Candy Darling (born James Slattery, 1944–1974): Superstar. Strikingly beautiful drag queen with platinum-blond glamour; referred to "her" penis as "my flaw." (Other drag queen superstars are **Holly Woodlawn** and **Jackie Curtis**.) Died of cancer at age 30.

Baby Jane Holzer: Superstar. Dubbed by the press "1964's Girl of the Year," this beautiful socialite found starring in Warhol's films more fun than being a Park Avenue housewife. She later invested in an ice-cream emporium in Miami Beach, Florida, and is now an independent art dealer and real estate investor in New York City.

Fred Hughes: Elegant Texan, assistant at the de Menil Foundation in Houston when he and Warhol met. He became Warhol's companion, manager, and, later, the executor of his estate and the head of the Andy Warhol Foundation for the Visual Arts, Inc.

Gerard Malanga: Studio assistant who made himself invaluable from the start by knowing how to silkscreen. A poet, he brought his bohemian scene to the Factory. At the time of Warhol's death, he worked for the New York City Department of Parks & Recreation.

Paul Morrissey: Cameraman. His close involvement with Warhol's film production led him to take over directorial duties after Warhol's near-fatal shooting in 1968. *Frankenstein* (shot in 3-D) and *Dracula* are essentially Morrissey films, produced by Andy Warhol. Morrissey lives in Brooklyn and Los Angeles.

Billy Name (born Billy Linich): Studio superintendent. He furnished (with stuff he found on the streets, including the infamous maroon couch) and silvered (with spray paint and aluminum foil) the first Factory. His photographs are extraordinary documents of early Factory life. Billy is based in New York and continues to work as a photographer and author of "concrete" poetry.

"Pope" Ondine (Robert Olivo, 1939–1989): Studio assistant. Warhol's 1968 book, *a (a novel)*, is a transcribed tape recording of a day in the life of this "A-man," whose amphetamine habit kept him talking for days on end. He died of cyrrhosis of the liver after years of dependence on drugs and alcohol.

 Edie Sedgwick (born Edith Minturn Sedgwick, 1943–1971): Superstar. Drop-out daughter of a rich family; fashion model who sensationalized her own Pop look—druggy waif in mascara. She became Warhol's Princess of Pop, traveling with him to Paris in 1964, carrying nothing but a spare white mink. Died of a drug overdose at age 28. Subject of the biography *Edie: An American Biography*, by Jean Stein (edited by George Plimpton).

 Ingrid Superstar (born Ingrid von Scheffen): Superstar. Warhol credited this "nice girl from New Jersey" for introducing him to the term *superstar*. In the mid-1980s, she left her home in Kingston, New York, one day to buy a pack of cigarettes and vanished, never to be heard from again.

(Left to right) Other Warhol superstars include **International Velvet** (born Susan Bottomly), **Ultra Violet** (born Isabelle Collin Dufresne), **Viva** (born Susan Hoffmann), and the voluptuously beautiful **Joe Dallesandro.**

with only the vaguest instructions to the dealer on how to cut, stretch, and install the show. Coincidentally, a major exhibition of Marcel Duchamp's art opens concurrently in Pasadena, where Warhol meets the high priest of Dada himself. He also hobnobs with movie stars at a party thrown in his honor by the actor and photographer Dennis Hopper.

All-American Andy

Andy Warhol loves America and is devoted to the idea that within this **Pop paradise,** democracy is the great equalizer—for better or for worse. The richest consumers drink the same Coca-Cola as the poorest, wear the same Levi jeans, enjoy the same movies, and (allowing, of course, for different denominations—Catholic, Jewish, Hindu, etc.) worship the same God whose eye appears on the capitalist dollar bill!

Current Events

Back at the Factory, Warhol's silkscreen images continue to mark current events, and to create them. In 1963, he commemorates the *Mona Lisa*'s visit to America from the Louvre Museum in Paris, where the painting resides, in a series entitled *Thirty are Better than One* (on page 12). He is already working on silkscreens of **an electric chair, car crashes, suicide, and race riots** when President Kennedy is assassinated on November 22, 1963. Shortly thereafter, Warhol starts his *Jackie* series of the widowed First Lady in mourning. Using photos taken hot off the press and printing them on canvas singly or in numbingly repetitive

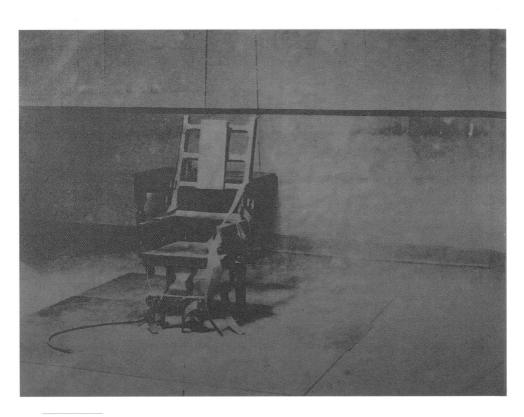

Electric Chair
1967. 54 x 73"
(137 x 185 cm)

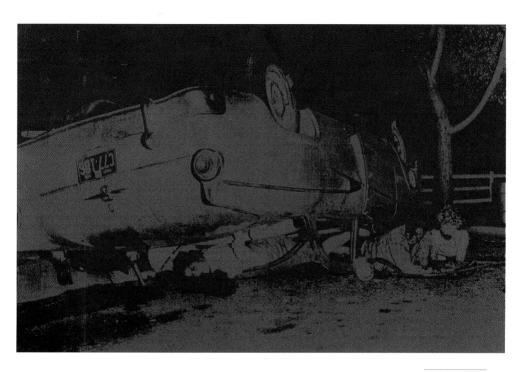

Five Deaths
c. 1963. 20 x 30"
(51 x 76 cm)

16 Jackies, 1964
16 panels, each
20 x 16"
(51 x 41 cm)
total dimension
80 x 64"
(203 x 163 cm)

grids, Warhol reproduces the current phenomenon of being inundated with these images. Going straight to the heart of America's collective consciousness, these images provoke strong reactions. Simultaneously tragic and sensational, emotional and exploitative, they can make you feel **angry and sad** (how could anyone kill John F. Kennedy, a man whose brilliant handling of the media made him *America's first celebrity president*), **annoyed and manipulated** (as if the invasiveness of the press isn't bad enough, what business does Warhol have using these brutal images as art?), **frightened and panicky** (Warhol lives in fear of accidental death in a world graphically filled with violence), and **numb** (the repetition is enough to dull any feeling, *but what better defense against the shock of these events?*).

Sound Byte:
"It was just to show the passage of time from the time the bullet struck John Kennedy to the time she buried him."
—ANDY WARHOL, 1967, on the motivation behind his *Jackie* series

FYI: Grids—Not found in nature, *grids* mean "this image is a product of culture." They are the underlying structure of Jasper Johns's alphabet and number paintings of the 1950s. In Warhol's art, grids further suggest rows of strips of film, shelves of products, and endless mechanical reproduction.

BOX ART: *BRILLO BOX*, 1964
Synthetic polymer and silkscreen on wood
17 x 17 x 14" (43 x 43 x 33 cm)

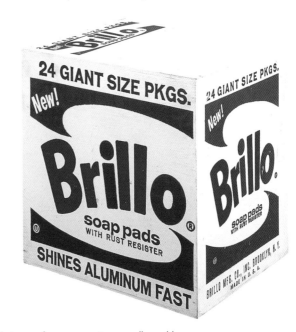

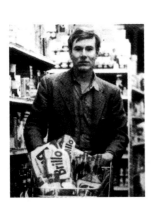

Andy in a supermarket
1964

What: One of many similar sculptures of a grocery-store cardboard box.

How to make: Warhol sent assistants to the supermarket to bring back sample Brillo boxes and discovered that the cardboard would not hold paint properly. So he hired carpenters to build wooden boxes, then painted them white and silkscreened each side to reproduce the labeling of the actual cartons.

Minimal effort: While Warhol directed the procedure, he had virtually no hand in *making* this sculpture. From this point in art history forward, artists (of all stripes) increasingly use outside fabricators to create works in which concepts are more important than handcraft.

So what's the big concept? To make art look like a consumer good.

Food chain: As art, these empty boxes call out: "Buy me." *What a subversive message in the sooo refined art world!* In a commercial art gallery, where art *is* the business, sales are hush-hush, back-room transactions. In museums, artworks appear elevated beyond such crass propositions. And in a private collection, "Look what this bozo bought" is certainly part of the original message of Warhol's Box Art.

Cool thing to know: Usually art travels duty-free. But when a group of Warhol's *Boxes* went to Canada, customs officials billed the usual 20% tariff on *incoming merchandise.* Not only had Warhol's concept worked, but the ensuing legal battles won him more delicious PR!

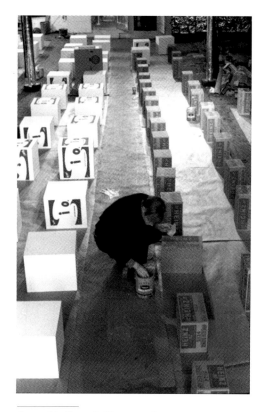

Assembly line of silkscreened boxes at the Factory, 1963

Just Criminal (Or "Why Pick on Me? Act II")

When Warhol is commissioned by architect **Philip Johnson** to create a work for the 1964 World's Fair, the artist provokes a **scandal.** He emblazons the New York Pavilion's façade with portraits of *Thirteen Most Wanted Men,* using their FBI photos. The finished work is censored by officials and Warhol agrees to cover it up. Using **silver paint,** he makes it more conspicuously sensational than ever. Warhol had already turned himself into the subject of a series of 1964 silkscreen paintings based on a form of Pop photography, **the photo-booth portrait.** The previous year, he shoved collector Ethel Scull into a photo-booth, where she hammed it up beautifully, as seen in her Warhol silkscreen portrait, based on the session. Warhol installs a photo-booth in the Factory to facilitate his photo play.

Arriving and Retiring

For his 1964 exhibition at the Stable Gallery, Warhol stacks the gallery with towering rows of his new Box sculptures, perfect facsimiles of cartons for **Brillo** soap pads, Kellogg's corn flakes, and Heinz ketchup. The

Santi Visalli, Inc./Archive Photos

installation transforms the gallery into a grocer's storeroom full of merchandise, inexpensively priced to move. Warhol envisions the boxes flying out the gallery door in the arms of happy Pop collectors. Wrong! Few of them sell, which sours his relationship with the Stable Gallery. So when the long-awaited call arrives, inviting him to join the Leo Castelli Gallery, Warhol easily moves shop.

His first show with Castelli, entitled "Flowers," opens in November 1964 and is a sellout. It features a single photographic image of four flowers, thematically attuned to the prevailing hippie aesthetics ("flower power") of the times. Reproduced in various sizes and colors, they are hung in grids, floor to ceiling. Friends see a commemoration of Warhol's friend, the dancer **Freddy Herko**, who had recently fallen to his death after gracefully leaping through a plate glass window. Collectors see cheery Pop pictures. The following spring, Warhol travels to Paris for the opening of a second Flowers show, where he announces his retirement from painting. He tells the press that he plans to devote himself to *film*. As if to mark the end, **the first retrospective of Warhol's career** is held at the Institute of Contemporary Art in Philadelphia. The opening is mobbed; many bring soup cans for Warhol to sign. It is the fall of 1965.

Underground Filmmaker and Impresario: 1965–68

Put the tape on rewind and go back to the summer of 1963, to the beginning of Warhol's film career. While weekending in Connecticut,

OPPOSITE TOP
Andy at the
Factory, 1968

OPPOSITE
BOTTOM
Ethel Scull, 1964
20 x 16"
(51 x 41 cm)

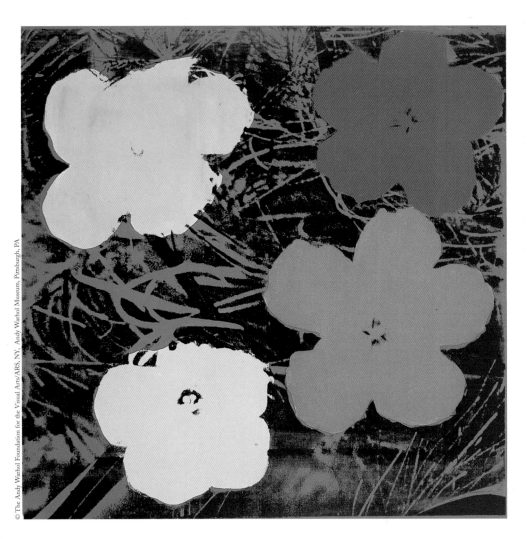

© The Andy Warhol Foundation for the Visual Arts/ARS, NY. Andy Warhol Museum, Pittsburgh, PA

he meets the underground filmmaker **Jack Smith,** whose works are notorious for their outrageous camp and polymorphous sexuality. Smith is shooting a new film, *Flaming Creatures,* which prompts Warhol to run out and buy a camera. Among his first efforts is a short homage to his mentor entitled *Andy Warhol Films Jack Smith Filming Normal Love,* and the wholly original and seemingly interminable *Sleep,* a 5-hour, 21-minute film of his friend John Giorno sleeping naked.

OPPOSITE
Flowers, 1967
48 x 48"
(122 x 122 cm)

> **FYI: Andy's Tape Recorder—**In 1964, Warhol gets his first tape recorder. It becomes his constant companion—*he calls it his wife*—which he uses to document conversations, interviews, and general ambience.

Sound Byte:

"The acquisition of my tape recorder really finished whatever emotional life I might have had, but I was glad to see it go."
　　　　　　　—ANDY WARHOL, THE *Philosophy of Andy Warhol,* 1975

Back in New York, he starts attending screenings of underground films organized by filmmaker **Jonas Mekas,** who will become Warhol's great champion in cinema. By 1964, film is Andy's central activity. His painting factory now supports a film studio.

ANDY WARHOL'S CINEMA

Andy Warhol filming, 1967

See it coming: From his childhood infatuation with Shirley Temple, to his silkscreen paintings of Marilyn and Liz, films are in Warhol's stars.

Film packages: Warhol's films draw freely on Hollywood, experimental films, and pornography.

Early works: Silent films in which the camera remains fixed on its subject, sometimes for hours; the only editing is to splice one reel to the next! (Avant-gardists applaud these *cinematic endurance tests*, which earn Warhol a place in film annals as the first director whose camera work expressed absolutely no opinion.)

Beautifully BORING!!! More flagrantly than his paintings, the early minimal films embrace *an aesthetics of boredom*. Warhol—who was known to flip through magazines, make phone calls, or simply leave the room while the camera rolled—suggested that they make nice wallpaper.

Later works: These improvisational narratives (with soundtracks) of people not exactly "acting" show people being their exhibitionist selves for the camera. Pop audiences love the *sexploitation*, which wins Warhol credit for legitimizing explicit sex on the American screen.

Some of the highlights:
Empire, 1964. The sun sets and rises over the Empire State Building in this eight-hour film.

Edie Sedgwick in
Outer and Inner Space, 1965
Reel 1 on left;
reel 2 on right
16mm film
b/w, 33 min. in
double screen

© 1999 The Andy Warhol Museum, Pittsburgh, PA, a museum of Carnegie Institute

Henry Geldzahler, 1964. A 99-minute portrait of Warhol's friend sitting on the couch.

Screen tests: During 1964–66, Warhol films 500 b&w short portraits of Factory visitors realizing the Pop dream of being discovered on film. (In 1971, Warhol adapts this project to video, when he starts to tape *Factory Diaries*.)

My Hustler, 1965. (Rumor has it that the cast and crew reeled on LSD-spiked breakfasts while making this one.) Men and women scheme for Paul America, who plays a studly young Dial-a-Hustler who comes to entertain the Long Island weekenders. This Warhol hit is considered the model for director John Schlesinger's Oscar-winning *Midnight Cowboy* (1969).

Outer and Inner Space, 1966. A double-screen video-based film installation in which 22-year-old superstar Edie Sedgwick (on the right-hand screen) has a *real-time*, 66-minute dialogue with her own videotaped image (on the left-hand screen). The film recalls the silkscreened multiple images of Jackie Kennedy and Marilyn Monroe. It is Sedgwick at her finest.

The Chelsea Girls, 1966. Another double-screen movie; Warhol's greatest critical and commercial success. A voyeuristic peep into the seedy sexy lives (and rooms at the bohemian Chelsea Hotel at 222 West 23rd Street) of Warhol superstars. Hovering between fantasy and reality, this hallucinatory work—two reels run side-by-side for 3 1/2 hours—plays to sold-out theaters. *Newsweek* dubs it "the *Iliad* of the underground."

Essential thing to know: In 1972, Warhol removes his films from distribution in order to market his relatively mainstream production company, Andy Warhol Films, which operates at escalating costs, culminating in the million-dollar picture *Bad*, a 1976 cult classic about an electronic hair-removal specialist who runs an all-female crime ring. (Warhol's own directorial efforts are only now beginning to be conserved and re-released by The Andy Warhol Foundation for the Visual Arts.)

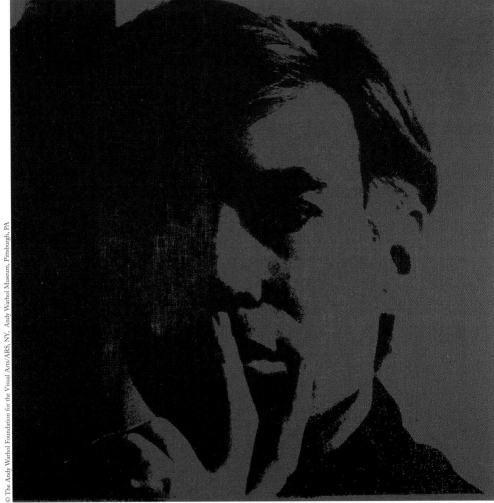

© The Andy Warhol Foundation for the Visual Arts/ARS, NY. Andy Warhol Museum, Pittsburgh, PA

Andy's Exploits

Warhol's retirement from painting is an excellent marketing strategy: "Quantities limited, buy your Warhol now!" Despite his 1964 announcement, he continues to make art but downplays its production in relation to his films (and later, to his television and magazine enterprises). Seeking a larger public, **Warhol becomes an outrageous self-promoter** during the late 1960s. In New York, he runs a newspaper classified ad offering to endorse any object with his signature. In Michigan, he *presides over a Pop wedding* that offers a honeymoon trip to the Factory. Across the nation, he sends a *Warhol impersonator* on a college lecture tour. The latter stunt backfires when a student later notices that the artist bears no semblance to the "Warhol" he photographed on stage—actually Allen Midgett, a young man masking his part-Cherokee descent under tons of silver spray paint and powder. Faced with having to return the fees, Warhol re-does the tour in person, taking with him from the Factory a small entourage, who happily speak for him. *Gee!*

OPPOSITE
Self-Portrait
1967. 22 x 22"
(56 x 56 cm)

> **FYI: Warhol Rocks**—Warhol designed two of rock-'n'-roll's most infamous album covers: The Velvet Underground's 1966 debut album *Peel Slowly and See* (a banana with a peel-off vinyl skin and a pink fruit) and the Rolling Stones's 1971 *Sticky Fingers* album cover (a boasting blue-jeaned hunk with a working zipper).

Gallery Scene goes Night-clubbing

In 1966, Warhol **packages** elements of contemporary Performance Art for Pop consumption in the form of *The Exploding Plastic Inevitable* (aka EPI). A distilled Factory scene, the EPI "Happening" features:

Nico, 1966

- **sound:** the wailing dissonance of the pre-punk band **The Velvet Underground** (Lou Reed, John Cale, Sterling Morris, Maureen Tucker) that Warhol hears play at the Café Bizarre and undertakes to promote with **Nico** (born Christa Päffgen), a German fashion model with ice-queen beauty, who drones gloomily before The Velvet's wall of sound. (Nico died in 1988 at age 49 of head injuries sustained in a bicycle accident.)

- **light:** enormous projections of Warhol's films bathe the performers in colored lights.

- **eurethmics:** on stage, Gerard Malanga cracks a **whip** while Edie Sedgwick **go-go dances.**

- **drugs:** the total environment reproduced—and was conducive to—**mind-altering experiences.**

Clubbin' at the Castelli Gallery

For his 1966 exhibition at Castelli, Warhol injects a shot of night-club energy into the art gallery. He fills one room with about 50 floating

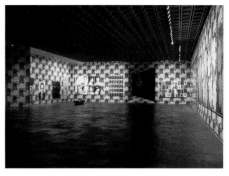

ABOVE
Cow wallpaper, 1971. Installation at
Andy Warhol exhibition at The Whitney
Museum of American Art

LEFT
Cow, 1976. Screenprinted on wallpaper
45 ½ x 29 ¾" (116 x 76 cm)

Silver Clouds (Mylar pillows filled with helium; see page 78) and hangs the other with *Cow* wallpaper (the sweetest face you've ever seen, tarted up in hot Pop colors on an acid-yellow background) to create an environmental installation, a space for things to happen.

SILVER CLOUDS, 1966
Helium-filled metalized plastic film, dimensions variable

What: Metallic Mylar pillows filled with helium. (Mylar was a new technology in packing materials.)

How: Produced with E.A.T., a collective cofounded by engineer Billy Klüver and artist Robert Rauschenberg (among others), aimed at encouraging **Experiments in Art and Technology.**

Mirror Mirror: The *Silver Clouds* bobbed around like floating mirrors, conjuring all kinds of associations, from Warhol's Silver Factory to Warhol (Mr. Mirror) himself, from sheer narcissism to one of the oldest metaphors of painting as *a mirror held up to nature.*

Hit or miss: Cheaply priced, the *Silver Clouds* still didn't sell. The helium leaked and the *Clouds* had to be routinely pumped up. They were a hit, however, with choreographer/dancer Merce Cunningham, who integrated them into the set décor for his 1968 dance performance *RainForest.*

"He controlled my life"

By 1967, the Silver Factory scene is spinning out of control from scary visitors, drugs, and violence. It is time to move on and get a new look. The second Factory is styled as a film studio with a reception area up front. On June 3, 1968, Warhol is standing there, chatting on the phone with Viva, when actress **Valerie Solanas,** an infrequent Factory visitor and fanatic, shoots him in the stomach and lungs with two bullets from a .32-caliber gun. The sole member of S.C.U.M.—the Society for Cutting Up Men—she had played a bit part in Warhol's film *I, a Man.* Solanas blames Warhol for losing the script to her opus *Up Your Ass* and claims he has too much control over her life. Immediately after shooting Warhol, she wounds his friend, the critic Mario Amaya, gets in the elevator, and leaves. She is arrested the following day. Bleeding profusely, Warhol is rushed to the emergency room in critical condition. Coming out of his operation, he learns that **Robert Kennedy** has just been assassinated. Warhol is hospitalized for almost two months. August marks his 40th birthday. (Solanas died of emphysema at age 52 in 1988.)

Valerie Solanas
1968

Sound Byte:

"It still seemed unreal, like watching a movie. Only the pain seemed real."
—ANDY WARHOL, on being shot, *POPism*, 1980

Andy Warhol: Business Artist (1968–87)

Times are changing. The Sixties are essentially over. Hippies, hustlers, and downtown freaks are going mainstream in Hollywood films like *Hair* and *Midnight Cowboy* (with Viva and other Factory folk playing themselves as extras). In keeping with the times, Warhol's art becomes increasingly colorful and *glam*. And though it's not an instant transition, after the shooting Warhol gradually retreats from the marginal downtown scene and enters into more protected stratospheres of society. There, he realizes his original ambition of **using art as a business for making money**. He begins by stepping up his **portrait industry**.

"Raid the Icebox"

In 1969, Warhol accepts an invitation to organize an exhibition. *Raid the Icebox* draws on the Rhode Island School of Design's permanent collection of fine and decorative arts. As ever, Warhol offers a novel display: He simply moves items from the storeroom into the galleries—whole racks covered with paintings, cabinets full of period costumes, and entire furniture collections. The installation replicates the **democracy** of storage, where the known and the unknown, the exquisite and the so-so examples all hang out together, flea-market style. (The exhibition also probably felt like home to Warhol, whose townhouse was filled with just such a sprawl of things.)

Warhol contributed significantly to a print renaissance in contemporary art.

Background: During the late 1950s, print-making took off as a vibrant medium when publishers, studios, and dealers committed to creating and selling limited-edition, artist-made prints and multiples (sculptural objects) began to spring up internationally.

Pop perfection: Given that prints were reproductions sold at relatively affordable prices, it was the perfect medium for Pop's commodity-as-art aesthetic.

A natural: For Warhol, it was a natural way to make money! His primary painting technique was already based on commercial printing. So unlike his peers, who created editions with special workshops, Warhol easily made prints another Factory production.

Once a star, always... Warhol's most famous print series was *Marilyn* (1967): 10 serigraphs of his already classic image, done in psyche-delic colors.

Tie-ins: Warhol used prints as a way of mass-marketing his work within the art world. He also used print-making to market his exhibitions. For his 1965 retrospective, he made *S & H Green Stamps* prints, blouses, and ties.

S&H Green Stamps
1962. 20 x 16"
(51 x 41 cm)

Portraits

ABOVE
Steve Wynn
c. 1977. 40 x 40"
(102 x 102 cm)

OPPOSITE
Mark Liebowitz
1977. 40 x 40"
(102 x 102 cm)

Portraiture becomes the mainstay of Warhol's silkscreen paintings during the 1970s and 1980s. He evolves several new bodies of work, each with its own distinct approach—depending, in part, on who's paying the bill. Except for certain series (Mickey Mouse was not personally available for his *Myths* portrait), Warhol no longer relies on found sources, such as magazine images and publicity photos, or on the novelty of the photo booth. A star himself, he can wait for the celebs to come to him. He takes the pictures using a Polaroid camera—always with a *blinding flash* that leaves the sitter looking dazzled. Here are some portrait highlights:

- **Vanity portraits.** Commissioned by celebrities, millionaires—such as Steve Wynn, owner of the new and dazzling Bellagio Hotel in Las Vegas, with its spectacular art collection and Dale Chihuly glass-sculptured ceiling—and unknowns (such as Mark Liebowitz), these portraits are Warhol's new main source of income. For these sittings, before shooting tons of Polaroids, Warhol carefully piles makeup onto his subjects—aiming to embalm them in the most flawless and Marilyn-like mask of their own

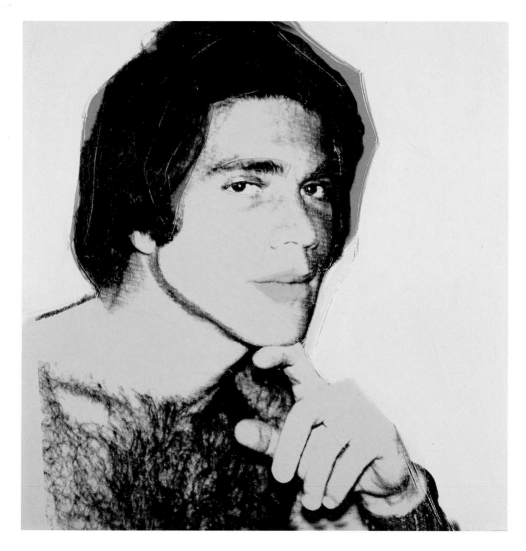

features. The artist is quite amenable to color suggestions from the client. *Can you really paint my hair to match my couch?*

- **Familiar faces.** In 1972, Warhol's mother dies in Pittsburgh. In 1974, Warhol commemorates her, along with living companions Truman Capote and Henry Geldzahler. Unlike the vanity portraits, Warhol does not glamorize them by concealing blemishes and wrinkles. *With such familiar faces, Warhol could not disguise his own fear of aging and death.*

- **Ladies and Gentlemen** (portraits of transvestites) and **Mick Jagger.** In these two series, both 1975, one sees Warhol's hand reappear. To the silkscreen portraits, he adds Expressionistic painting, slightly off-register contour drawing, and collaged swatches of color. These effects are reminiscent of Warhol's early and pre-Pop Art. They also establish an extreme new style of *painting as makeup,* enhancing the image. *Think of Warhol's late work as paintings in drag!!!*

- *Interview* **magazine,** Warhol's monthly portrait magazine, first appears in the fall of 1969 as a film journal. It quickly transforms into a fashion fanzine

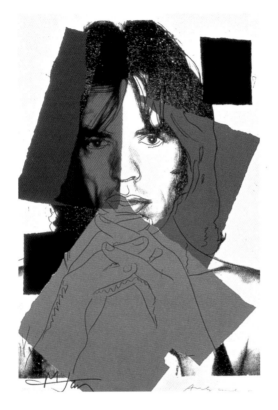

LEFT
Mick Jagger
1975. Printed
on watercolor
paper. From a
portfolio of ten
screenprints
43 $^1/_2$ x 28"
(110 x 72 cm)

OPPOSITE

TOP
Martha Graham
c. 1970
Polaroid print
4 $^1/_2$ x 3 $^3/_8$"
(11 x 7 cm)

BOTTOM
*Ladies and
Gentlemen*
1975. Printed on
watercolor paper
From a portfolio
of ten screenprints
43 $^1/_2$ x 28 $^1/_2$"
(110 x 72 cm)

with the glamorous face of some rock star, princess, model, or actor
Warhol knows (or wants to know) emblazoning every cover.

Like *Wow*, Man! Like Mao....

In 1972, Warhol commemorates Nixon's visit to China by starting work on his *Mao* series. Later that year, he makes a subversive presidential election poster with a portrait of Nixon, captioned "Vote McGovern." Warhol's Mao art culminates in a gallery installation in Paris. Regimented rows of Mao portraits hang on Mao wallpaper. From *Cow* to *Mao*, Warhol's wallpaper:

- puts a Pop spin on French Impressionist **Claude Monet**'s (1840–1926) famous wrap-around installations of his *Waterlily* series of paintings. *(After all, Mao did debut in Paris.)*

- is overtly decorative. It makes good on one of the criticisms dogging modern art; it looks like wallpaper. *(Looking good is more important than looking real.)*

- violates the art-world ideal of pristine white walls. *(In 1970, Warhol actually installs his retrospective at the Whitney Museum of American Art in New York on* Cow *wallpaper!)*

Sound Byte:

"I've been reading so much about China.... The only picture they ever have is of Mao Zedong. It's great. It looks like a silkscreen."

—ANDY WARHOL, c. 1972, on his attraction to Mao

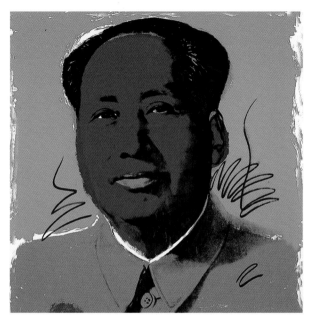

© The Andy Warhol Foundation for the Visual Arts/ARS, NY, Andy Warhol Museum, Pittsburgh, PA

ABOVE
Vote McGovern, 1972
Screenprinted on D'arches
watercolor paper. 42 x 42"
(107 x 107 cm).

LEFT, TOP
Mao, 1972. Printed on white
paper. From a portfolio of 10
screenprints. 36 x 36"
(91 x 91 cm)

LEFT, BOTTOM
Mao Wallpaper and *Mao
Paintings*, 1974. Installation
of Andy Warhol exhibition at
Musée Galliera, Paris

Photographer Jacqueline Hyde, Paris.

WARHOL'S WORK SPACES
Two Factories, an Office, and a Studio

1963–68

231 East 47th Street
(between 2nd and 3rd Avenues)
The "Silver" Factory. An industrial loft decorated by Billy Name, who covers everything with aluminum foil and silver spray-paint. It is the Pop movement's epicenter, where a cast of characters come and go, or stay indefinitely. The production of Warhol's art and films is just one attraction in this nonstop carnival environment, until the building is razed. (***Cool thing to know:*** A decade before Warhol's Factory, Robert Rauschenberg had spray-painted his studio silver.)

1968–74

33 Union Square West
(between 16th and 17th Streets)
The Factory. The entire sixth floor is divided by a wall into a whitewashed office/reception area (in front) and a blacked-out screening area (in back). On the white walls hang vintage photos of 1930s' movie stars (including Shirley Temple), head shots of Warhol superstars, and, in block letters, titles of Warhol's films. Rent hikes send the Factory packing. (The Factory is located in the middle building in this photo.)

1974–84

860 Broadway
(northwest corner of Union Square)
The Office (also called the Factory). The huge space also houses Warhol's *Interview* magazine staff. Opulently decorated with Art Deco antiques, the office is guarded like a fortress. For example, Mick Jagger or David Hockney comes to lunch in the paneled conference room. He steps off the elevator into a vestibule with a security camera before being buzzed through the steel door into a reception area. A stuffed Great Dane stands guard, scrutinizing visitors (see page 90).

1984–87

22 East 33rd Street
(a block east of the Empire State Building)
Warhol Studio. Having been a renter until now, Warhol buys this former Con Ed building and moves his entire enterprise here. (Since 1974, he's been residing in a townhouse at 57 East 66th Street.) It is an eccentrically appointed but elegantly run operation.

© The Andy Warhol Museum, Pittsburgh, PA

Photograph © Paul Rocheleau

TIME CAPSULES

The Andy Warhol Museum, Pittsburgh

What: Basic cardboard boxes that Warhol sends to storage filled with...*endless surprises.*

How: In 1974, Warhol formalizes this art project—which began as a pack-rat problem—when he starts *systematically filling boxes* with personal memorabilia he has kept since childhood—dentist bills, stolen hotel towels, photo-booth strips, reels of film, exhibition catalogues, Velvet Underground records, newspaper clippings—basically, whatever comes his way on a day-to-day basis. Once filled, the carton is whisked into storage and replaced by a fresh, empty box.

How many? Warhol creates 610 Time Capsules.

Archiving for all eternity: Part of Warhol's archive, the Capsules are being opened one at a time and their contents inventoried, item by item. The wealth of information they contain is staggering and even a little absurd. *Hey, are those* really *Clark Gable's shoes? Yes, the movie star's widow sent them to Warhol as a gift, which he ceremoniously encapsulated!* Altogether, the contents elaborately detail the complexity of Warhol's interests, ambition, achievement, and art.

OPPOSITE
"Cecil," the stuffed Great Dane, standing guard near the boxed *Time Capsules.* In the Archives Study Center, The Andy Warhol Museum, Pittsburgh, PA

Warhol's Books

THE Philosophy of Andy Warhol (1975) is the artist's Pop version of Mao's *Little Red Book* of wisdom to live by. Warhol's eminently quotable commentary on art, sex, fashion, society, and consumer trends proves *just how shrewdly he conceptualized his art and strategized his career* in relation to contemporary culture. It's a tad misleading to say he "wrote" the book, since his best-known books—*Philosophy* (1975), *POPism* (1980), and *The Andy Warhol Diaries* (1989)—were penned by Pat Hackett, based on daily telephone conversations with the artist which she taped. (Want to know why the *Diaries* contain so many references to cab fares and price tags? Because Warhol was always being audited by the IRS, and Hackett's Factory job included keeping account of Andy's expenditures—such as all those cab rides to Studio 54 for "research and development.")

ABOVE
Studio 54 VIP drink tickets
c. 1976–78
Paint on canvas
26 x 14"
(66 x 36 cm)

OPPOSITE
Diane Von Furstenberg
1974. 40 x 40"
(102 x 102 cm)

Glitterati

In 1977, with his circle of celebrity friends—the designer Halston, singer Liza Minelli, designer Diane Von Furstenberg—Warhol starts hanging out at the chic discothèque **Studio 54.** While engaging in this glitzy version of the Factory scene, he is now completely inaccessible, hidden away in the VIP private party rooms, surrounded by money and dalliances of every kind. (In honor of Andy's 50th birthday party, club owner **Steve Rubell** dumps a trash can full of $100 bills over Warhol's *happy* head.)

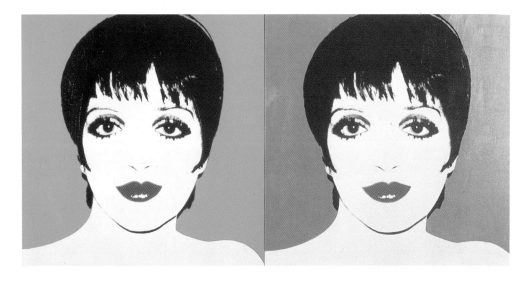

© The Andy Warhol Foundation for the Visual Arts/ARS, NY, Andy Warhol Museum, Pittsburgh, PA

When Warhol moves the Factory to a new facility in 1978, he drops the name "Factory" and calls his new studio **the Office.** From blue collar to white collar, Warhol the art-worker turned art-businessman keeps perfectly apace with the advancing next decade of **triumphant conservative culture**—*yuppies, Ronald Reagan, Wall Street raiders, big hair, bigger dresses, and cocaine.* In the spirit of Eighties excess, Warhol sprinkles real diamond dust over his 1980 silkscreens of shoes.

Return of the Commercial Artist

Warhol's highly visible Pop style finds corporate clients beating at his door to get him to design ads for Absolut Vodka, Mercedes Benz, fashion and jewelry designers, and *(get this)* Campbell's Soup. A consumer item in his own right, Warhol signs up with a modeling agency (first Zoli, then Ford) and appears in advertisements for TDK videotape, Drexel Burnham investments, and Diet Coke. With all this celebrity, can television be far behind?

TV Andy

When Andy Warhol gets home at the end of a long day at the office, and a hard night out *working* the town, he turns on the television. (He is also addicted to the telephone, talking to friends for hours at a time, the TV blaring in the background.) He is fascinated by this quintessential Pop medium—think of the mass audiences—and longs to make it his own. In 1984, when he moves operations for the fourth and final time, he calls his new base **the Studio,** associating it as much with television production as with art. He gets his big chance in 1985 when *Andy Warhol's Fifteen Minutes,* a program based on the *Interview* magazine format, hits the MTV airwaves.

Dead Man Walking

But it's not all business pleasure. Warhol's booming portrait industry

OPPOSITE

TOP
Liza Minelli
1978. Two panels
each 40 x 40"
(102 x 102 cm)

BOTTOM
*Ad for
Van Heusen
(Ronald Reagan)*
1985. 22 x 22"
(56 x 56 cm)

Shadows, 1978
Installed at Andy Warhol
Museum, Pittsburgh, PA
Each canvas 76 x 52"
(193 x 132 cm)

and commercial art provide the financing for experimental and tough new works. The latter hint at some of the pain and fears that Warhol struggles with after the shooting. Look for:

- **monumental scale.** *Shadows* is one work made up of 102 **huge** paintings; the ambiguous imagery (what is it a shadow of?) is filled with awesome emptiness.

- **self-historicizing.** Warhol begins to reproduce iconic images from his past art in two 1979 series: *Reversal* (where images appear in negative: black on colored grounds) and *Retrospective* (where images are spliced together in cinematic clusters).

- **abstraction.** He turns photographs of naked male torsos into highly formal paintings that he calls "landscapes." Mapping the mind, he creates *Rorschach* paintings (see page 99), inspired by the ink-blot tests used by psychoanalysts.

Piss painting, 1978
Urine on gesso
on canvas. 12 x 9"
(30 x 23 cm)

RIGHT
Self-Portrait
1981. Polaroid
photograph
4 $\frac{1}{4}$ x 4 $\frac{5}{8}$
(11 x 12 cm)

OPPOSITE
*Self-Portrait
with Skull*
1977. Polaroid
photograph
4 $\frac{1}{4}$ x 4 $\frac{5}{8}$"
(11 x 12 cm)

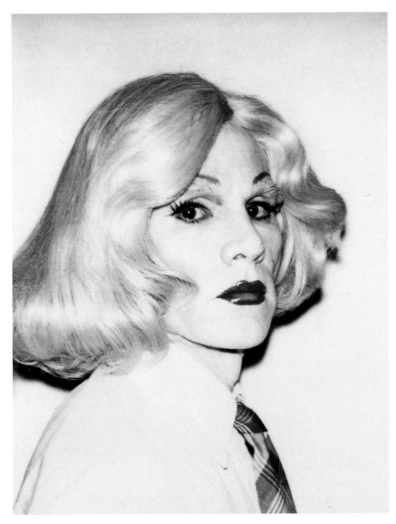

LEFT
Rorschach, 1984
20 x 16"
(51 x 41 cm)

OPPOSITE
Torso, 1977
50 x 38"
(127 x97 cm)

- **savage cynicism.** In his seductively beautiful and abstract *Oxidization* series (also called "the piss painting," as seen on page 97), Warhol turns earlier riffs on Abstract Expressionism into acid satire by urinating on copper paint.

- **ruthless self-portraiture.** When it comes to portraits, if Warhol is unsparing to his friends and family, he is downright devastating to himself. These images play up his freakish looks and despairing expression (*Camouflage Self-Portrait,* 1986), his anxieties (*Self-Portrait with Skull,* 1977), and his perversions (in *Polaroids,* he appears caked in white face-paint and in drag).

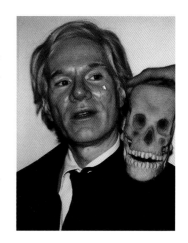

Sound Byte:

"If I'd gone ahead and died ten years ago, I'd probably be a cult figure today."
—ANDY WARHOL, *POPism* (1980), contemplating his own survival

Loving Warhol

A consummate voyeur who liked to look and listen **but not touch,** even in his sexual relations with other men,

*Jed Johnson
with Andy's
Dachshund
"Archie"*
14 x 11"
(36 x 28 cm)

Warhol was always discreet about his love life. (He was more forthcoming about his love of pornography.) After a 12-year relationship with the handsome **Jed Johnson,** who abandons Warhol in 1980 to pursue a career as an interior designer, Andy makes a big play one year later for the affections of a 27-year-old Paramount Pictures executive. **Jon Gould** is reluctant to be perceived as Warhol's "boy toy" but finally agrees to move in to the bedroom above Warhol's, provided that Warhol helps him purchase an apartment at the Hotel Des Artistes at Central Park West and 67th Street, which he will use as his official mailing address. When the young man leaves Warhol in 1984 and moves to California, the artist feels betrayed and bitter. Thank goodness for his faithful dachshunds, Archie and Amos, and his friends. (Tragically, Jed Johnson died in the TWA Flight 800 crash off the coast of Long Island, New York, in the summer of 1996. Jon Gould died of AIDS at age 33 in 1985.)

Fond Collaborations

In 1983, Warhol becomes friendly with—and collaborates with—several young downtown artists, all of whom are affiliated with **Neo-Expressionism,** most significantly **Jean-Michel Basquiat** (1960–1988). Warhol and

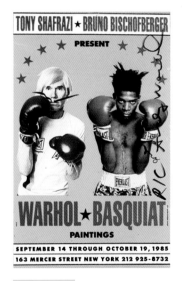

Exhibition poster for the Warhol/Basquiat show at the Tony Shafrazi Gallery SoHo, 1985

Jean–Michel Basquiat
Synthetic polymer paint on canvas
40 x 40"
(102 x 102 cm)

Basquiat's joint canvases are the subject of exhibitions in New York and Zurich. (Basquiat, who signed his works "SAMO," was heralded within the art world as "a radiant child" for his brutal, naïve-looking graffiti art. He soared the dizzying economic heights of the 1980s' art world and died at age 27 of a heroin overdose.) While the show is not a critical success, the poster, showing both men in boxing gloves, is terrific.

A Divine Touch

The big thing that comes out of Warhol's artistic collaborations is that for the first time since the early 1960s, he starts *painting by hand*. He has already returned to drawing, often working late at night alone in the studio, filling sketchbooks. In 1986, using a projector, he paints a major series of large-scale images based on Leonardo da Vinci's **Last Supper** fresco. It is, in fact, the last work that Warhol will see exhibited in his lifetime. On February 20, 1987, he checks into New York Hospital. Although he has been in excruciating pain for weeks, his morbid fear of hospitals causes him to postpone what promises to be a routine operation on his gall bladder. Everything goes well; the post-op patient is perky before retiring to the care of his private nurse, who is so deep in her Bible reading that she fails to notice he has become overhydrated and has turned blue. Then it's too late. After a hospital team attempts to resuscitate him, Andy Warhol is pronounced dead on February 22, 1987. He is 58 years old.

THE LAST SUPPER, 1986
40 x 40" (102 x 102 cm)

What: A Pop rendition of Renaissance artist Leonardo da Vinci's *The Last Supper* (1495–97), a fresco of Jesus Christ breaking bread with his disciples for the last time before he is betrayed and crucified.

Factory ritual: *Did Warhol identify with this image?* He was always surrounded by an entourage of devotees, especially at meals. During

the late 1960s, faced with all these mouths to feed, Warhol ritually traded artworks against his running tab at **Max's Kansas City,** a hip restaurant on Park Avenue South, around the corner from the Factory.

How: In 1986, Warhol produced a variety of *Last Suppers.* Some are silkscreened, while others are hand-painted using an overhead projector to enlarge the image onto huge pieces of canvas.

Dig the drips? They mark Warhol's return to hand-painted Pop, a place he hasn't visited in his art since the early 1960s.

Endorsements: Emblazoned over the sacred supper are profane insignia for contemporary consumer items.

Heavy Church: Catholicism and consumerism were Warhol's religions. He attended church regularly and spent holidays serving food in soup kitchens. He saw himself as a sinner surrounded by profanity and excess.

Papal blessing: Many in Warhol's entourage were also lapsed Catholics, including Fred Hughes, with whom, in 1980, Warhol had an audience with Pope John Paul II.

Spiritual America: You can see this painting as the culmination of Warhol's Pop religious pantheon: Jackie as Madonna, the electric chair as crucifixion, Marilyn as martyred saint.

Exhibited: The *Last Supper* series was commissioned by an art dealer who arranged for the works to have their premiere exhibition at the Palazzo delle Stelline in Milan, *right across the street from the original fresco!*

*Last Supper
(Mr. Peanut)*, 1986
102 x 118"
(259 x 300 cm)

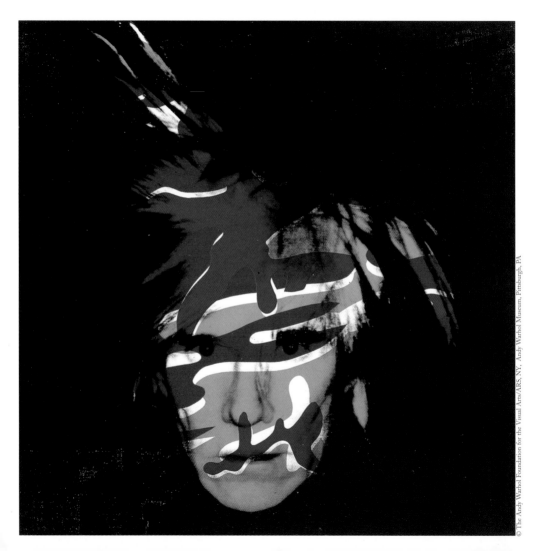

© The Andy Warhol Foundation for the Visual Arts/ARS, NY, Andy Warhol Museum, Pittsburgh, PA

Pop Apotheosis

At his funeral in Pittsburgh, Warhol's brothers bury the artist in a solid bronze casket, and a friend tosses two copies of *Interview* into the grave. On April 1, 1987, a memorial celebration is held at St. Patrick's Cathedral in New York City, attended by more than 2,000 people, from collectors to underground artists. Warhol's former studio assistant, Gerard Malanga, makes the most eloquent Pop gesture by wearing a T-shirt silkscreened with the front page of the *New York Post*'s headline *ANDY WARHOL DEAD AT 58*. The will makes provision for the creation of **The Andy Warhol Foundation for the Visual Arts,** which collects over $25 million after a ten-day Sotheby's auction disposes of the contents of Warhol's 27-room townhouse. (Warhol's biographer, David Bourdon, says the place was crammed with "everything from Picassos to Miss Piggy memorabilia.") In 1994, **The Andy Warhol Museum** opens in Pittsburgh to exhibit and preserve the artist's art and archives.

The American Dream

Andy Warhol lived the American dream and survived one of its nightmares. Born into a working-class family of **immigrant origin,** Warhol went to college, came to New York, got a job, and then through hard work and ingenious enterprise rose to the top of his profession(s), first as a **commercial artist,** then as a **Pop artist.** He worshiped fame and

OPPOSITE
Self-Portrait
1986. 40 x 40"
(102 x 102 cm)

became a **celebrity.** During a decade of assassinations of American leaders, he was **almost murdered** by a deranged wannabe. A product of the consumer culture, he called his work "business art" and used all the strategies of marketing to promote its success—shock, sensation, supply-and-demand, sex. He died a legendary art-world figure in command of vast financial and cultural empires.

Essentially a Concepts Man

Art is a commodity. Art is reproduction. Art is empty. These are the radical concepts that Warhol promoted—concepts that had incredible impact on contemporary art for a Postmodern era. The history of Modernism—from Claude Monet to Jackson Pollock—is driven by a sense of progress, of art moving forward through artistic abstraction and invention to create visual meaning. Then *wham!* comes Warhol, a painter who makes an entire career of reproducing existing images, including (in his later work) his own art. Warhol's paintings proclaim, "Why bother making new pictures? The world is already filled with them." Ultimately, his quintessential

*Myths
(Mickey Mouse)*
1981. Printed on
Lenox Museum
Board. From a
portfolio of ten
screenprints
38 x 38"
(97 x 97 cm)

Postmodern art shows a culture adrift in a constant flow of images from advertising, movies, the press, fashion, and art. All of it is there to **consume;** it's just a matter of packaging. And, as we know, Warhol (*the 1960s soup-man*) was the consummate packager and promoter— not only of paintings, prints, drawings, sculpture, and gallery installations (high culture), but also of commercial illustration, films, discos, books, bands, publicity stunts, and virtually all other forms of Pop (low culture). For Warhol, it was all part of **one big (democratic) consumer culture.** The fact that he actively participated in this culture at the same time that he *distinctly* stood apart from it and envisioned it is Andy Warhol's enigma and his genius.

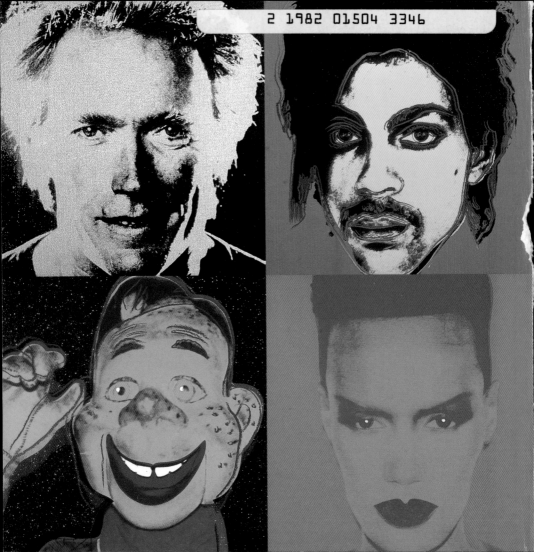